Some architectural p To-day

Sir C. H. Reilly

Alpha Editions

This edition published in 2023

ISBN : 9789357964104

Design and Setting By
Alpha Editions
www.alphaedis.com
Email - info@alphaedis.com

Contents

I.

THE CHARACTER OF OUR CIVIC BUILDINGS.

IN civic architecture the clothes are the man. We can judge other people's buildings only by their appearance. From the depth of the window jambs and door reveals we may gather something of the apparent thickness of the walls; and from the point of view of appearance it is the apparent thickness, in spite of Mr. Ruskin, which counts.

As citizens we are interested only in the exterior of the vast majority of buildings. We want them built of sound materials, which will last and weather pleasantly, because we do not want to see our towns look shoddy. These towns are the most self-revealing things we make, because they are to a very large extent the unconscious expression of ourselves in the mass. There is very little conscious direction in the matter, even since the passing of the Town Planning Acts. Each person within the limits of certain rules laid down for public safety and health builds as his fancy dictates. Only one town in England so far insists on the elevations of all new buildings on its streets being submitted beforehand for approval by the public authority, and in that town—Liverpool—the authority has not yet taken steps to secure that it is better advised in matters of taste than it was before it had these powers.

There is every reason, therefore, that the public should take as keen an interest in its new buildings as it does in its new books and plays—more reason, indeed, because the latter need not be seen, and the buildings must. No man builds to himself alone. His building is there, if in London, for some ninety years or more. It may even descend to our great-great-grandchildren to show them what sort of animals we were. The unveiling of a great building when the scaffold first comes down should be an important event, much more so than the unveiling of the ordinary statue.

For instance, very shortly Sir Edwin Lutyens' great building in Finsbury-circus and Moorgate for the Anglo-Persian Oil Company will be exposed to view. Here is the first great modern block of offices being built by one of our leading architects. Will Sir Edwin, who has been so successful in giving suitable character and individuality to a vast number of country houses, be equally sucessful in imparting the impersonal dignity and reticence required for the due expression of a solid commercial undertaking? From the drawing in last year's Royal Academy one is pretty sure that he will, and that by this building he will set a new standard for the city. But one may safely say it will be some time before the general public discovers the

building, and perhaps a hundred years before it takes any genuine interest in it. We are apparently just waking up to the beauties of the Bank of England, built about 100 years ago, now that it is threatened.

Architecture, then, for some obscure reason, although she is the ancient mother of the plastic arts, and the one from whose embraces none of us can escape, herself escapes criticism. No one writes to the papers to say what a vulgar and pretentious building the new War Office is, or how badly Mr. Selfridge's great block is behaving both to its neighbours and, indeed, to the whole town by its arrogant bearing. You would think from looking at its vast ornate colonnade that shopkeeping was really the height of our ideals, and that there was something after all in Napoleon's gibe.

In these days, when in the Arts, at any rate, national feeling is dying down—have we not recently gone so far as to erect a monument inspired by German art to Nurse Cavell?—and when the ages of faith are past, and there is no great wave of enthusiasm for any particular form of expression, such as existed as late as the Gothic Revival of last century—a time, and one remembers it with gratitude at least for its seriousness, when architects' offices were opened with morning prayer—it is all the more necessary to make sure that the character of our town buildings conforms to some standard of public decency.

In clothes we all feel the necessity of this. We have a code of urban manners in dress and a code of country ones. The town code unfortunately of late years shows some signs of weakening. Men in "plus fours" have been seen in our best streets, but buildings in similar garments are there always. A great insurance company has built itself a new building in the Strand, and roofed it with the split stones of a Gloucester farm house. Why not thatch our banks straightaway?

We often hear of the damage the town is doing to the country, but do we so often realise the far more serious damage the country is doing to the town? Think of its inroads in every direction, town houses masquerading as country ones and suburban ones as village ones. There was a time when suburbs were proud of their connection with the town, and showed it by their architecture, and even by the carefully selected trees in their gardens— the pendant acacias and laburnums, the rounded weeping ashes, which consorted well with the classical buildings. Now suburbs are only too anxious to turn their backs to the town, and pretend they belong to the country—a thoroughly snobbish and suburban proceeding, when but for the town they would not exist.

In the eighteenth century most people lived in terraces of houses, in which externally each individual house did not differ materially from its neighbours. This was a fine sign of urbanity, a tribute to the community,

just as much as the black coats most people affect in London to-day. Any excessive expression of individuality or of personal importance in a building was considered bad manners, just as it is in dress, only with this important difference, that bad manners in dress soon disappear, while bad manners in architecture remain.

In the real country things are different. The spaces between buildings are wider, and there is little bond of corporate union to be expressed. In the depths of his own domain every Englishman feels he can do what he likes, though in other matters he is even there a sufficient stickler for good form. "Good form" in every sense of the term is what is needed more than anything else to-day in civic building. The old words, "civil architecture," express exactly what is desirable. Our town buildings should pay a conscious tribute to our civilisation instead of being merely an unconscious revelation of it.

II.

OUR RECENT GOVERNMENT BUILDINGS.

SIR WILLIAM HARCOURT once caused considerable irritation, especially amongst architects, by applying some words of Byron's to New Scotland Yard and calling it the most recent, but the least decent, of our public buildings. Immediately a great number of architects began writing to the papers to say that Mr. Norman Shaw was a great man and by inference his Scotland Yard was a great building.

It certainly was, and is, in many ways, and yet I think Sir William Harcourt was quite justified. Scotland Yard departed from our national tradition in public buildings. Till then we had not taken as a prototype, even for a super-police station, a German *Schloss* or a French *Château*. Scotland Yard is that clever and impossible thing, a compromise between the two—a sort of reparations settlement with England left out. One is inclined, therefore, to call such a compromise indecent.

Now one assuredly does not want to stress too highly national character in architecture, but if it is to show anywhere it should be in the national buildings. In these since the Renaissance (and it is not much good going back earlier, though we did it to our cost in the Houses of Parliament) the established custom, amounting to a tradition, has been a Portland stone building in the palatial Palladian manner. Somerset House is the great example. It is thoroughly English, yet dignified without being dull or pretentious. Great columns are used sparingly, as accented syllables, to emphasise certain portions of the façades. It is obviously related by cousinship of design to a number of the larger private mansions throughout the country, but in a British Government office one must expect that. Looking at it from all sides, from the Embankment, Wellington Street, and the Strand, it is not only of sufficient height and mass to be impressive, without being overwhelming, but it has the right London scale. Its parts are neither too big, like Selfridge's, nor too little, like the Savoy Hotel's. No doubt when the water washed into its magnificent rusticated arches and it stood reflected in a clear Thames it must have been finer still. But there it is to-day, setting an unsurpassed standard to all the newer work. In the pearly beauty of its Portland stone it seems to be calmly rebuking both the provincial note of red brick in Scotland Yard and the domestic note, which the great red-tiled roof gives to that offspring of Scotland Yard on the opposite side of the river—the London County Hall.

If, then, with the memory of Somerset House in our minds, we walk down Whitehall we shall have a standard by which to judge the great new Government buildings. There are three of them, the upright rectangular block of the Woods and Forests building, the great colonnaded block of the War Office, with its two corner domed turrets, and the large Home Office block at the bottom on the right hand, which goes on endlessly with more and more towers and projections, as a palace should, down Great George Street. If we cannot quite retain the quality of Somerset House in our minds we can refer to another genuine antique, as we do in our furniture, for a standard—Inigo Jones's Banqueting Hall. Any building which can live up to that in scale, repose and refinement, though it was the first of its type, will survive for all times.

At first you think the Woods and Forests building is rather good. It is big and bold and strong. It is well made, its composition is satisfactory, and it is weathering to a beautiful colour. But it has no distinction. It is better than Joe Beckett, but not as good as Carpentier. Its columns are the ordinary unfluted columns of commerce, while its entrance porch might be the entrance to a new Whitehall hotel—in Bloomsbury. However, one must not say too much against it or there will be no epithets left for the War Office.

The War Office is another of these buildings which at first glance is deceptive. A great Liberal peer once announced in reference to it, "There's a model of what public building should be!" If he had made his money since the war, or because of it, I could have better understood him. I think what takes the public fancy in the War Office is its silhouette coming up and down Whitehall. It stands out very prominently at a break in the street. Its great range of independent columns in perspective is very effective. So are its two cupola-covered turrets at either end of the façade. Its composition is an obvious one, easy to grasp. It is such a good advertising front that Messrs. Robinson and Cleaver have made a caricature of it for their new premises in Regent Street. But when you have glanced at it from the top of a passing omnibus you have seen it all. It will not bear looking into. If the Woods and Forests building has no real distinction of manner the great pile of the War Office bears itself like some tired Titan. No consideration or feeling has been given to the detail. The same meaningless blocked columns appear endlessly to every window and door. Cast your mind back to Somerset House or look further down the road to the Banqueting Hall, or across it to the Horse Guards, and you see that another race built these things. It is sad, but it is true. Otherwise how is it that an eighteenth-century building is as seldom wrong as a modern one is right?

The one that is nearest right of our three great new offices is the last, and that it must be confessed is because it is nearest to the eighteenth

century. Mr. Brydon, the architect, worked in Bath. Now in Bath you cannot escape the eighteenth century unless you are an extraordinary person like the designer of the Empire Hotel in that town. Mr. Brydon did not try. He absorbed as much of it as he could digest. Yet his big Home Office block is no mere "as you were" building. It is not an eighteenth-century copy, but it is sufficiently eighteenth century not to be vulgar. I will not say it is great architecture, like the Banqueting Hall, yet it has a certain amount of dignity and distinction. The great columns, for instance, have been fluted, but the delicacy of the fluting does not reappear in the rest of the building as it does in the old Treasury block close by. That is all of one piece and at a high level. Rarely do we achieve that nowadays, and certainly not in a great public building. When we do we have to go to an artist like the late E. A. Rickards or to Sir Edwin Lutyens, men whose personalities and taste are both sufficiently vivid and strong to fuse the diverse elements of modern work into a consistent whole.

If I were asked to name the best modern public building in London I should unhesitatingly say E. A. Rickards's Town Hall at Deptford. But that is some way from Whitehall.

III.

THE OFFICE BLOCK.

BUSINESS and busy-ness are not the same thing. One does not necessarily imply the other. The designers of our modern blocks of offices, especially in the City of London, do not seem as a class to have grasped this. Had they done so the City, where a greater amount of new building has been done in recent years than anywhere else, would not look so trifling and unconvincing as it does. The buildings have not the same serious air as have the lower portions of those in Wall Street and the end of Broadway— one takes no notice of the upper portions when close at hand.

No one from its recent architecture would realise that the city is still, in spite of the war and unheard-of debts, the centre of the world's money market. The new buildings, for instance, which now line King William Street, compared to an old building, like the Sun Life building in Threadneedle Street, or to the modern American banks and Trust buildings, are skittish and flamboyant. In spite of the size and apparent wealth of these King William Street ones, you would expect exaggerations in any prospectuses issuing from them. They have that air—an unfortunate one—of over-emphasis.

In Lombard Street, which I suppose is more expensive still, so expensive indeed that only concerns of the highest financial standing in the world can afford to exist beside its narrow road-way, there are even worse examples. In so narrow a thoroughfare every canon of good taste would call for flat reserved façades, yet instead we have in the newer structures, buildings of the strongest modelling and the highest ornateness. In one case a great group of colossal half-naked women is leaning out over the street from the pediment of the main entrance, and in so commanding a way that you are tempted from it to make a guess at the purpose of the building. Is it a slave market, or something worse? No; it is only a highly respectable insurance company of the very finest status and credit.

Even in Kingsway, where a much higher standard of taste prevails than among the average city buildings, we find great new blocks of an extraordinarily complicated architecture. Pelion is not only piled on Ossa, but is interpenetrated with it. We find the buildings like this till we come suddenly to the great new American building which closes the vista—Bush House. Here is a clean-looking structure with regularly spaced windows, all of the same size, devoted to ordinary office purposes. Even in its present

unfinished state, with only about one-fifth built, anyone can see that it is a strong and effective mass, with no fuss anywhere to interfere with its outlines. Riding down the Strand on an omnibus one carries away from it, in one's mind, a definite impression which one certainly does not of its be-whiskered neighbours. One remembers its clear-cut appearance and the interesting detail about its arched entrances. It is an impression of dignity and character obtained without any obvious struggle. No complication of columns decks its façade in the false pretence that it is a palace or to be used for palatial purposes.

In this respect compare Bush House with the Assurance Office on the opposite side of the Strand, which combines a farmhouse roof of split stones with an order of giant columns, and below these a disorder of large ladies leaning out above the ground-floor windows in considerable déshabille to watch the traffic. Nevertheless, in spite of, or rather because of all the extra excitement, one forgets it. It leaves no image on the mind. By overdressing, in place of the simplicity of a good cut, the building has become ineffective.

The Bush building, by a good cut and little ornament sparingly used, is highly effective. Its great entrance on the Aldwych front must be judged in connection with the great plain wings yet to be built on either side and the tower to crown the group. This front is, of course, designed as a terminal feature to Kingsway, and a magnificent one it will make when complete. The building will have, I imagine, a very great effect on all subsequent office blocks. In such matters it introduces, not only American efficiency with its well-lit and easily divisible floor space, but American economy of expression. We have, in reality, always taken business seriously in this country. Perhaps, at last, we shall appear to do so.

I trace a good deal of the flamboyance which has spoilt our business buildings in recent years not only to the flamboyant and rather vulgar architectural period from which we are just emerging, but also to the narrow frontages on which so many of our business premises have in the past been built. The building owner is anxious that his new building shall be distinctive, shall possess what his estate agent calls "a good advertising front." As the site is a narrow one something extraordinary has to be committed on the façade to mark it from its neighbours. The extraordinary things demanded have been forthcoming, and our streets have, in consequence, become the haphazard muddle, not unpicturesque in general effect, of which Fleet Street and New Bond Street are good examples. Economic reasons, however, are now bringing about bigger buildings. To develop economically one site, another is added to it. The same battery of lifts, for instance, which the greater number of stories calls for, can serve both. With this increase in size the composition of the buildings is an easier

matter. They can have breadth, in both senses of the term. They often stretch now from side street to side street, or at any rate have one flank showing. The total mass, therefore, is not only big enough, but has an opportunity of telling, and the architect is no longer so tempted to strive for his effect with extravagant ornament and eccentric forms to his smaller features.

Sir John Burnet is building a fine stark structure, called Adelaide House, at the foot of London Bridge. It rises sheer from the water to a height of some 120 feet. It has little ornament, yet the building is going to be one of the most powerful in London. It will tell like the Bush building by its general shape and mass, and like it, too, its detail is free from all ostentation.

The square sites provided by the gridiron plan of American cities are one of the reasons for the simpler shapes of American buildings. We shall never reach the monotony of such a plan, and we may be thankful for it; but with the bigger buildings which are now coming into existence we, too, may have the advantage of more island sites, and of buildings therefore, which rely on solidity for their effect, and not on narrow faces, ugly or not, as the case may be, but always trying very hard to catch one's attention.

IV.

BANK BUILDINGS IN ENGLAND AND AMERICA.

WHY does a New York, a Montreal, or a Toronto bank differ so much in the character and quality of its architecture from a London or Liverpool one? All appear to the average man to serve the same needs. Money may be more powerful on the other side of the Atlantic than it is with us, but it is hardly more respected. Yet there the banks provide temples for their customers while we provide saloon bars, mahogany partitions and all.

The modern American or Canadian bank consists of a great dignified hall, so large and lofty that the counters and such few screens as there are appear, in relative size, like the furniture in a ducal drawing-room. This hall is not generally of ornate architecture, neither are multi-coloured marbles used. It is usually a well-proportioned, lofty apartment of simple rectangular shape, free from intermediate columns, not unlike the best rooms in the British Museum. If a polished stone or marble is used it is generally Roman travertine, with its quiet, warm texture. It is difficult to generalise, but one might state with some degree of accuracy that the architectural scheme is mostly one of large flat pilasters, with a Roman coffered ceiling. That is to say, it is one of architecture reduced to very simple elements. Nothing is allowed to interfere with the great impression of dignity, even of solemnity, which awaits you directly you pass through the revolving doors. You are impressed almost in the same way and to the same degree as you are when you first pass into a cathedral. The service may be going on—it is all the while in the bank—but it is the building which holds you.

When you come to examine it in detail you see about the base of the big pilasters, and evenly spread over the floor of the larger part of the cella— one cannot get away from the temple feeling—a number of small human beings busily at work. These humans are protected by low stone enclosure walls, surmounted in some places by the most delicate and beautiful small bronze grills and screens, or marble ones with bronze in-filling.

I noticed with interest in the National City Bank, New York—the Bank, I was informed, of the Standard Oil magnates—that these screens were of delightful Early Christian detail. I did not complain of any inappropriateness. I admired them intensely. They provided a charming foil to the great Roman interior, with its detail derived from the Pantheon.

They may have been at the same time some private tribute to early martyrs in the cause of oil, but that did not matter.

Across this expanse of heads you see, or think you see, the presidents and vice-presidents of the institution. There seems to be no concealment in private rooms. Everyone is there to be shot at when the hold-up comes, and not merely a few cashiers. Architecturally, the result is magnificent. The most insignificant depositor can walk up and down the great hall and either enjoy the architecture or watch the machine working, according to his taste. If he wants to talk to the head of a department he is not taken away to a small room, but to a low armchair placed beside that official's desk. So great is the floor area that there is perfect privacy by the mere space between the desks.

Think what all this means to the architect designing the bank. Apart from vaults below, his work consists in giving dignified expression, externally and internally, to one great hall. The finest materials and workmanship are at his disposal. Was there any problem like it, at once so simple and so splendid, since the days of the Greek temples?

Instead, what do we do? Firstly, we very rarely consider a bank worthy of being an independent building. It generally has other offices over it. The only one I remember which expresses the banking hall as a single unit is the fine National Provincial Bank, in Bishopsgate, which was built some time in the 'seventies by John Gibson, and still remains externally our finest bank building. But one would not mind the offices over—they have sometimes to have them in America—if the banking hall itself were realised by the bankers and their architects as the splendid opportunity it is for noble architecture.

It is difficult to think that we really believe in banking, as the solid serious profession we talk about, when our banks are not only nearly as numerous, but very like our public-houses. Both are more often than not glorified corner shops. There is the public bar and the private bar in each. The public bar is of any shape so long as there is sufficient counter space, and the private bar or manager's room has the same mahogany and frosted glass. Externally, each shows, too, a nice taste in pink, polished granite.

In the smaller country towns, however, there is a good deal to be said for the more domestic character of our banks, though, as the greatest builders in the country at the present time, the five big banks have not a very distinguished record even there for good and suitable work. One does not want in a Cotswold village the Ionic temple of Main Street.

In the Metropolis or the big provincial cities, however, it is clear to anyone who has crossed the Atlantic that our banks have not yet risen to their architectural opportunities. It is not that they have not spent enough money. It is that their buildings have not been fine and austere enough. They have, in short, not treated their banking business sufficiently seriously.

V.

THE SMALL SUBURBAN HOUSE.

NOT only at election times, but always under modern conditions, the very small house is the most important unit in our towns. As long as the mechanic, the small tradesman, and the black-coated poor prefer to live in separate dwellings under separate roofs, each thinking of his little box of bricks as an Englishman's castle, their little houses will occupy a larger space than any other type of building. Even the escaping motorist, leaving his responsibilities and his smell behind him, cannot be entirely unaware of the miles of dreary side streets down which he glances for an oncoming bicycle or milk cart before he reaches the open country. Those who travel by train, omnibus, or tram car, are even more conscious of them, the former seeing not only their little grinning faces, as alike as a row of Mr. Studdy's puppies, but also their untidy Mary Ann backs, with their strips of desolate garden or yard, each decorated with a pole for wireless or for washing.

What stale, vulgar mind or minds brought about this desert of mean streets, all potential if not actual slums, which is one of the most distinctively English features of our towns? As far as I can see, the minds which were ultimately responsible for them were minds replete with the very best intentions engaged in drawing up model by-laws in Whitehall.

Beauty and by-laws do not at any time live very happily side by side. The few towns like Chester which have none, may have slums, though not very many, but they still retain some of the beauty which a good building tradition alone can give. Model by-laws destroy tradition, destroy independent design, and for all small town property put architects out of work. Let us see how this comes about.

Following the Public Health Acts of 1875, which at any rate gave us water-tight or approximately water-tight drains, most municipalities, instigated by Whitehall, thought they could apply to buildings with equal success the same sort of rules they had applied to drains. They began, therefore, to lay down the minimum thickness of all walls, the minimum strength of all floors, indeed, the minimum size of practically everything. We were not to be allowed to fall through our bedroom floors even if we wanted to.

So far so good. But what was the result? At once the minimum became a maximum, but that alone would not have mattered very much. More

happened. Anyone could now build to satisfy the authority, because everyone was told how. Hence arose the standard minimum little house and the jerry builder who dealt in them as others dealt in peas or potatoes. Why go to an architect, why have any thoughtful design at all? Copy the model by-laws, and all will be well. Your plans are bound to be passed. They were, and the result is what we see—minimum roads, minimum houses, maximum repetition, and maximum vulgarity.

You may ask why the latter? The answer is because the jerry builder was not wholly a bad man. It would have been much better if he had been. He had just a little conscience, and that was represented by the decorated bay window, and the stained glass over the front door. I use the past tense, for he has practically gone, clever man that he was in many respects, and has retired probably to a multiple edition of his own residences, all gables and conceit, at Bournemouth, or some similar place. But before he went he left his indelible mark on all our towns where there is a belt of his work, one to six miles wide, as a permanent memorial to his pre-war faith in model by-laws.

The position has altered because the margin of profit on which the jerry builder worked does not now exist in the case of the smallest houses, and because the model by-laws have been remodelled. The speculative builder—we will no longer call him by his sobriquet, for we are all very anxious he should start work again, if not quite on the same lines—has now to confine himself to slightly larger houses which he can sell. There is a chance, therefore, that he will have to consider the external design a little more carefully, and perhaps even employ an architect, though the newest little houses in places like Bournemouth have all the same old flapper-like features, the same ostentation and desire to make an immediate impression, while at the same time turning a cold shoulder to the neighbouring house. These are the marks of an uncivil, unurbane, suburban mind, in the modern and worst sense of that term.

The hope is in the smaller houses, which are too expensive for the speculative builder at the rents that can be charged. These are therefore being erected everywhere, though not nearly fast enough, by the municipalities under the various Government schemes. Everyone must have been impressed by the general improvement in design which has come about. The loosening of the by-laws has meant the employment of competent architects both for the lay-out of the roads and for the houses themselves. Instead of long narrow roads of closely packed minimum houses we have now groups of three and four houses of simple shape, which being simple can combine into some sort of unity.

The fault in the present housing schemes, good as they in general are, is, I fancy, that the units are too dissociated. We have gone too far in the opposite direction. We want, I think, more terraces, of anything up to a dozen houses, lineable with the road. We want more of the effect of a village that has grown, rather than of a lot of little model houses squeezed out of the same mould and dotted about on the landscape. But the change has been wonderful, and the chief step towards that change has been the un-modelling of the model by-laws.

VI.

OUR BIG RAILWAY STATIONS.

ONE reads in the daily papers that one of our biggest railways has commissioned a set of posters from most of the painter-members of the Royal Academy. Whether the R.A.s are equal to this effort in design remains to be seen, but one may take the action of the London, Midland and Scottish Railway as a sign of grace—if not exactly a death-bed repentance. After the spirited and successful deeds of the London Underground in this respect, the bigger railways had to do something. Being big, they naturally thought of the Academy; from a great combine one cannot expect any very tiring effort in clear thinking.

But what has all this to do with the big railway stations? I think it lies very near their heart. It gives at any rate a clue to the strange mystery of their shapelessness. The big railway termini in America have no posters, but are in themselves fine architectural schemes. The big termini in this country, especially the recent ones, like Victoria, have no architectural scheme, but plenty of posters. One can imagine the English director saying, "It does not matter about the shape of our stations if we plaster them with these," and then, more touchingly, "If we go to the Royal Academy for the plasters, all will indeed be well."

This state of mind, of course, exhibits a fundamental error of the most primitive kind. Our railway companies to-day seem to have as little faith in their own enterprises as do our banks. If railway transport is the great and important thing a great many people, not even excluding all railway directors, think it to be, the thing in itself is worthy of fine expression.

The terminal station is the gateway of the town, but a gateway through which people are brought from the uttermost parts or through which they set out on illimitable journeys. What structure in the whole of our civilisation should make a finer appeal to the imagination? Yet if we think of our London termini, only King's Cross and Euston express in any sense this gateway idea, and in the latter an hotel belonging to the railway has been allowed to impinge upon and spoil the great gateway symbol—the Doric Propylea—which Hardwick, the architect, invented for this very purpose.

For the rest, our main railway stations are big railway sheds, leaning up against hotels or blocks of railway offices, the details of which are necessarily entirely out of scale with the spans of the train-shed roof.

Sometimes this roof, as at St. Pancras, is in itself a fine thing; sometimes, as at Waterloo, it is, in the words of Mr. Roger Fry, a series of hen-roosts. In no case in England in recent years has the real dignity and importance of the railway as a railway been allowed or given anything like full expression.

In New York the problem has been approached quite differently. There the town has seen in the first place that the railway tracks are below the ground level, and that no steam engine enters the town to befoul it with its smoke. At the Great Central Station there are two tiers of tracks, one for main line and one for suburban traffic, one above the other and both below the surface. With us, especially in the southern lines, the reverse seems to be the general rule. Our railway companies, regardless of all amenity, carry their tracks high in the air, thereby cutting off large districts by embankments and generally deforming the town.

With the sunk railway tracks in New York the structure above ground is left free, and the station problem resolves itself, on the practical side, into gathering together the passengers in the most comfortable way and sending them down to or up from the right railway track at the right time. On the architectural side, the American method has meant that an architect of repute has been called in to express above ground the majesty of the particular railway, while using, of course, the plan forms most convenient to passengers. When he has done that and has thereby made the finest possible advertisement of that particular railway, no other kind of advertisement, either of the railway itself or of anything else, is permitted within the station.

I remember well a New Yorker's first view of one of our own termini. He turned to me and said "Say, man, it's a vaudeville show." And he was right. Compared with the great halls of the American stations, our Waterloos and Victorias are comic opera inside and out. Theirs are monumental structures, through which pour with ease vastly greater crowds than we deal with, for New York, with practically the same population as London has only two great terminal stations.

The fact is our stations take any shape left over by the engineers. No architect of the first rank has been employed since Hardwick at Euston, on any great terminal station, whereas Charles Follen McKim—the Christopher Wren of America—conceived and designed the Pennsylvania Station, and two slightly lesser men had almost more success with the Central Station. Our railway companies are generally content to give the engineer an architectural assistant or to keep in their employ a tame architect, who works for no one else, which is in itself but another confession that they consider the shape and form of their stations a question of very secondary importance.

Such a view is, of course, at once vastly unpatriotic, an insult to the intelligence of the community, but also a mistake, one would think, on purely commercial grounds. No American walks through the immense concourse hall, lined with Roman travertine, of the Great Central Station in New York or penetrates the series of halls, like some vaster Baths of Caracalla, of the Pennsylvania Station, without a sense of pride in the two great railway companies who have given the country such noble monuments. The average New Yorker feels to these two stations as the average English schoolboy does to express engines. He takes you to see them. Who takes anyone to see Waterloo or Victoria? Who is impressed by their combined red brick and stone cinema-architecture? But no one fails to be impressed by the vast, simple Roman architecture of the New York stations or the great triple arched façade of the Union Station at Washington.

The Americans believe in architecture; they know its value at its best as both the most abstract and at the same time the most powerful form of human expression, and their railway magnates have the sense to make use of it. Instead, ours go to the Royal Academy for pretty pictures with which to cover up their disgrace.

VII.

RELIGIOUS BUILDINGS OF TO-DAY.

NO one could call ours a temple building era. Yet more, and more truly, religious buildings seem to me to have been built during the last twenty or thirty years than in any equal space of time since the dissolution of the monasteries.

This may seem a strange statement when we look back on the fervours of the Tractarian movement and the endless Gothic churches it produced—and one might almost add the endless Gothic cathedrals it destroyed. Looking at that handiwork one begins to wonder whether the medieval movement of last century was after all really a religious movement based on any real feeling or just a sentimentally romantic one.

How is it that this so-called irreligious age in which we live, and this certainly a vulgar one if we are to judge it by its civic buildings, has produced ecclesiastical buildings which are living and vital things, while that Victorian age, in spite of its hymns and its prayer meetings, its battles of the styles and its religious arguments, produced mainly, if not entirely, dead copies, or rather travesties, of worn out past architecture?

It is a strange paradox and one which I think can be explained only by the fact that under the mass of neglect and indifference with which religion struggles to-day, a few enthusiastic artists are able to work with a freedom which was denied to their fellows in the second half of the nineteenth century, when every layman was an ecclesiologist and every parson had some half-baked theory of medieval art of his own, which he felt it his duty to run. What chance had the poor architect when his style was dictated to him and confined to some fifty years of a century itself five centuries old? Yet that was everywhere the common practice. Archæology reigned supreme, the only difficulty being that the exact fifty years for imitation and revival changed from time to time. It was a case of the dead not only burying the dead, but burying the living too.

To my thinking it was the interior of Bentley's great Catholic Cathedral at Westminster which finally broke the idea that Gothic, in one of its many past manifestations, was the only religious style. That grave and vast interior proved indeed that the requisite conditions for solemn building lay really in the opposite direction. It showed that lofty plain wall surfaces, even of common stock brick, were more important in giving the idea of remoteness and seclusion from the world than the richest clustered Gothic columns.

One felt after first seeing the Westminster Cathedral that even the Abbey nave, probably the most perfect piece of Gothic in England, if it were new to-day and fresh and unhallowed by endless associations, would not have the same power over the mind, the same humbling yet inspiring effect that this vast dimly lit hall of plain brickwork and concrete possessed. The very simplicity of its round arches, its sheer unbroken walls and piers, its plain sedate domes gave it a solemnity which richer and more articulate structures like correct Gothic ones could not from their nature possess. That it was, however, foreign and to a certain extent therefore esoteric in its appeal, while it made it no doubt very convenient to its particular purpose, rendered its style difficult if not unsuitable to general adaptation to ordinary and smaller churches.

The effect of Bentley's work, however, was none the less pronounced. It showed the Gothic architects of our churches, or certain of them who were open to new inspiration, that there were very impressive qualities to be obtained in church building which a strict adherence to past forms of Gothic could not give.

Gothic is essentially a linear style in which the eye travels along the well-marked lines of deeply indented piers, arches, and vaulting ribs. The interior of the Westminster Cathedral, on the other hand, especially before its decoration was attempted, had all the Byzantine feeling for large and finely modulated surfaces. Of strongly drawn moulded lines there were few. The world, we know, was shut out by high walls and another world suggested by the broad arches and domes, and by the very blueing of the atmosphere which their great height enabled them to bring about. How to get some of the strength and solidity of those walls and domes into ordinary church building was the new problem.

The solution was found in a new and free Gothic in which walls and solid piers took the place of Gothic columns and plain vaulting that of ribbed, in which the coloured stone lantern to which the old Gothic church approximated gave way to some form of massive interior lit by an occasional rich window. The new churches which I have in mind are buildings which look in on themselves rather than out on to the world. To the outside world they present a plain and often uncompromising exterior. They are in the world, but not of it—perhaps that, too, is symbolical of our time.

If it was Sir Gilbert Scott to whom we owe so much of the harder and less pleasing Gothic of Victorian times, as well as much destructive restoration of our Cathedrals, it is to his grandson, Sir Giles Gilbert Scott, to whom we owe to-day some of the best of these new free Gothic churches as well as, at Liverpool, the one great new Gothic cathedral of our

age. If anyone ever made good the sins of his grandfather, this architect certainly has. Though still a young man he has already built sufficient work to mark our era and to start a new renaissance in church building. It is a veritable renaissance in that the spirit of adventure necessary to a renaissance is there. His work, even the smallest, such as his church of the Annunciation at Bournemouth, has qualities of imagination and scale which place it in an entirely new category. While using Gothic detail for decoration he builds with the solid bigness of the Romans. It is too early yet to speak of his great cathedral, when but a third of a structure second only in size to St. Peter's, Rome, among Christian structures, has yet been completed, but there is already enough to be seen (especially now that a portion of the building is enclosed) for us to feel that at last we are to have a building which in the grandeur of its scale and the daring of its design will represent a greater individual effort of the imagination than that called forth by any cathedral yet erected in these islands.

VIII.

THE USE OF THE COLUMN.

THE classical column, together with its entablature of architrave, frieze, and cornice, commonly called the order, is one of the most abused features in modern architecture. It has, of course, come down to us, full of meaning and character, from Greek and Roman times by way of the Renaissance, each age, as it were, having laid its own deposit upon it. It has always, however, in the course of its long journey, retained something of its pristine importance and glory.

Coming to maturity, if not born, in temple, palace, and forum, the column has signified, even in pilaster form as in a wall decoration, something apart from and superior to the common daily activities of eating, sleeping and trading. It has been used on great churches and cathedrals, on palaces—though the Italians, unlike the French and English, seem on the whole to have preferred the latter with plain, cliff-like walls—on the fronts of town halls, theatres, and opera houses. It has come to mean, therefore, especially when of great size, something public and monumental or, in Georgian times, aristocratic. This feeling persisted even into the nineteenth century. We see in Regent's Park and the London squares terraces of houses with some columned or pilastered feature in the centre, or it may be the whole block is so treated. I suppose it was felt that what would be ostentatious in a single house was still permissible to a group. Where no one owned all the columns all could partake of their reflected glory and share it between them. In that way the order was not oppressive. With a duke, of course, it is different. He can have a columned house all to himself, but, then, both he and such a house are in themselves anachronisms.

So it was with the club. The Carlton might have columns—it had them galore, and still retains them—but the more austere clubs, like the Reform and the Athenæum, are above even a communal display of Corinthian glory. That they gain by their restraint all will admit. The order in these buildings is implicit, but not shown; as if the members of the club said, "We are, of course, as good as the Conservatives and the Guards; indeed, we are really such superior people that we have no need to advertise the fact, as they have to do, poor things!"

What, now, is the modern English use of the great order? The answer is, everywhere for every purpose. Where do we find its most conspicuous

example? In a great drapery store in Oxford Street. The particular store I have in my mind consists of nothing else—a great range of over-ornate columns, with a metal screen of windows between them. There is, of course, an imperial simplicity about such architecture. It might have been designed by a Roman Emperor in his cups. But he, at any rate, would have kept it for some Imperial purpose, if only as a house for his menagerie or his gladiators. Here, however, it is in the main an advertisement for "soft goods."

I maintain that that is all wrong, however well the columns and their accessories might be designed. If we use up our finest symbols on such structures, what have we left for really national buildings? The front of this Oxford Street store, when completed, will be more imposing, and in a way more effective, than that of Buckingham Palace.

Something is wrong here in our sense of civic values. Perhaps one need not mind very much about the front of Buckingham Palace being overshadowed (as long as the garden front remains untouched), but what are we to say to the British Museum? That is really important, and has of late years had a magnificent range of Ionic columns added in Montague Place by Sir John Burnet, who is, it is ironical to remember, the very same architect who is increasing the range of giant columns in Oxford Street. Having erected the one, he was probably considered the right person to erect the other. No doubt, too, he was, if the thing were right at all. That is the rub. I maintain it was not.

In the same way every lesser commercial building, except the few really great ones, like Bush House, at the bottom of Kingsway, ape the palace. Immediately opposite the Athenæum Club, on the other side of Pall Mall, is a new bank building, which is covered on every side with the commonest kind of unfluted Corinthian columns—the sort of columns a first-year architectural student draws because he can draw no others. Not content with adding large ones to the building as a whole and lesser ones to the attic, the designer here, whoever he may be, has added baby columns to the doors and windows.

Well, there it is, and you can contrast this early twentieth-century bank, aping royalty and achieving clownishness, with the early nineteenth-century club, refusing all such symbols (except in a small porticoed entrance, where the columns, serving a definite practical purpose, have another meaning) and achieving a nobility which seems almost past our dreaming about to-day. Yet Decimus Burton, when he designed the Athenæum, was only twenty-seven years of age. I am beginning to think we shall not again get architecture in England approaching his till we go to the young men of to-day of twenty-seven and there-abouts who can not only dream dreams, but,

like Burton, have received a complete training in the meaning of the symbols they use.

Columns having, then, a special meaning and significance, have, of all architectural detail, to be used with the greatest care. In Bush House, on the Aldwych front, they are used with great boldness, where they symbolise a great gateway at the end of Kingsway to what was designed as a great exhibition building, and with great reserve on the Strand front, where they chiefly announce the entrance to the office of the insurance company or bank which is to use, or uses, the ground floor. In an ordinary drawing-room we know what distinction they can give if introduced discreetly, and, on the other hand, what vulgarity if flamboyantly.

There is, however, a use of columns which has come down to us from classical times to which we do not, I think, sufficiently resort. It is the rostral column, independent and free-standing. Sir Reginald Blomfield has put one up in St. Paul's Churchyard and adapted it well to the architecture of the Cathedral. The Cunard Company in Liverpool have put up another as a war memorial in front of their magnificent block of offices on the river front, and have, appropriately enough in this case, completed it with ships' prows and a beautiful figure by Pegram. A free standing column, crowned with a figure, is a form of memorial which is always effective and rarely vulgar. The column in Waterloo Place to an obscure royal duke, called the Duke of York's Column, is perhaps, and especially in its setting, the finest memorial in London. If Liverpool ever decides to erect a war memorial it could not do better than repeat at the other end of St. George's Hall the fine column a better age put up to Wellington, so that the greatest post-classical building in Europe would lie evenly between the two.

Such single columns unattached to buildings necessarily take the severest conventional form. That is their safeguard, and that is why the Doric is better for this purpose than the Corinthian, why the Duke of York's Column is to be preferred so much to Nelson's.

Columns, however, that belong to a building at once assume, as well as partly dictate, the character of that building. Within limits, therefore, while belonging to the great traditional groups, they vary from building to building and age to age, but that is another and a very long story. At the present time I am convinced it would be a wise, if a self-denying, thing for architects to eschew all columns on the outside of their buildings, except for minor purposes, or in the rare event of some great national or municipal structure being entrusted to them.

IX.

THE EMERGENCE OF A NEW STYLE.

FOLK are wont to complain that there is no modern style in architecture; nothing but reproductions of past styles. Superficially there is something in this complaint which in itself is a very old one. The Victorian historians were accustomed to call all Renaissance and post-Renaissance architecture imitative, though what in the ancient world the Renaissance palace and the Baroque church—its two most distinctive products—imitated it would be difficult to say. The Italian giants themselves, like Alberti and Palladio, while boasting that they were building in the true Roman manner made quite sure that they were not, relying, I suppose, on the ignorance of their contemporaries as to what that manner really was.

So it is with a great deal of modern work. The architect's client may think he is getting correct Tudor, but he is certainly getting nothing of the kind. His very conditions as to content and arrangement probably preclude even the possibility of it. Still, one must admit with the greater knowledge of past styles, and especially of the Georgian ones, which exists to-day, a certain amount of clever "as you were" architecture is being built. For country and suburban houses it probably produces a better result than any "as you really are" architecture would do.

Where then is the new work and what is the new style that is as expressive of to-day as the Georgian work and style were expressive of the eighteenth century? Does the new style really exist? I think it does, or rather I think it is emerging out of the new conditions and the attempt to solve new problems. If so, it must be something more than a fashion, for a fashion is not a style. One may walk through a town to-day and date the buildings of every decade of the nineteenth century, and yet, after the first half of that century, there was no real development of style. The changes that took place from Classic to Gothic and back again with every impossible compromise between were at the dictates of fashion, but without any underlying need in the problems to be solved.

At last such a commanding need has arisen, and it is a new need. It is a need, too, which corresponds to a spiritual state, to an attitude of mind, to a way of looking at life. This being so, it is likely, in my opinion, to bring about a permanent epoch in design. It has already brought about in architecture a rough correspondence to the new forms of expression and to the simplification which has taken place in the other arts, showing thereby

that it is part of a widespread movement. It was there before the war, but it has been affected and strengthened by the war.

I can best describe the new style, which I think is emerging, by saying that it is a style which relies on volume and mass for its effects rather than on surface modelling. It is seen at its best in great new buildings like the Bush Building in the Strand, in similar ones in New York and in Berlin and in Hamburg. France, if she cannot dictate to the world, remains a law to herself. Its main quality is its starkness. It is a lean style, expressive at once of economy, efficiency, and steel construction. Economy is shown in the small scale of parts, in spite of the largeness of the mass, and efficiency appears in the simplicity of the planning.

Buildings in this style rise sheer from the street, with cliff-like walls in which the windows are spaced evenly, corresponding to the ant-like use of the building by a great number of different tenants. Columns and pilasters are disappearing, except as decoration to minor portions of the structure, such as to a few doorways, or to give a frieze effect under the main cornice or roof. They no longer decorate the building as a whole as they did in Georgian times. The Georgian pretence that every building or group of buildings was a palace gives place to the modern feeling that every building is a hive of industry.

Such blocks as I am trying to describe may be blocks of offices or flats, of factories or warehouses. They express modern forms of communal existence, and arise out of the high cost of building and the need for economy in structure and in space. They satisfy us spiritually because of the directness of their expression. In contrast to Victorian and Edwardian grossness, they are clean, lean, and ascetic. Such ornament as they have is in low relief and of the utmost delicacy and refinement. The carving on the Strand front of the Bush Building is again a good example. The winning design for the great Holt Line building at Liverpool—an office building to cost £1,000,000—is in the new manner, remotely Florentine, but really modern and post-war.

Anyone who has been to America recently must have felt, apart altogether from the high buildings, that its eastern towns express in their recent structures a new and sober, if rather ruthless, outlook on life. With the extinction of the individual owner and occupier, individual modes of expression are disappearing too. Buildings there are becoming elegant, efficient machines for multiple use by a vast number of persons. They are becoming almost as similar one to the other as the various makes of motor cars. Like the cars, too, they vary chiefly in size. That is their chief defect, their varying heights—soon, however, to be corrected by the zoning law—make for discontinuity. In shape, owing to the gridiron city plan, they can

vary but slightly. The total result, however, is not monotony, but a new sense of beauty and power. The isolated rectangular blocks, each catching the sun on one face, stand out as so many sentinel towers. With our continuous streets we shall never reach quite this effect, but steel construction, with its girders all at right angles to one another, and economy, calling for as much floor space combined with as little cubic space as possible, are together driving us in the same direction.

Our post-war desire for clean, honest, direct expression in all we do, with no secret diplomacy of construction or fallals of design, makes this new stark architecture something we can respect and understand. It must be remembered that starkness is in itself no bad quality. It is a quality to be found in Greek temples, in Florentine palaces, and in early Gothic naves. After the luscious, over-ripe architecture of the last twenty years, let us rather rejoice that it is again appearing in our buildings. These buildings may not represent a final stage in their own growth—they probably do not—but they do represent a very healthy reaction.

The small scale of the modern room in flat or office, with its low ceiling, compared to the large scale of the Georgian one, certainly represents a decline in value. Let us hope it is a temporary one, which will disappear in a generation or less, together with the present stringency. Spacious apartments mean spacious lives and spacious thoughts. But, at the same time, let us hope that our new cleanliness, our new freedom from worn-out shibboleths of detail and ornament, may remain, and the directness and simplicity we have won become a permanent asset of our architecture.

X.

WHO DESTROYED OUR TOWNS?

SOME may think the obvious answer to this question is "those who covered our towns with soot." But this is a superficial view. Wash the soot away and the shapes remain the same. My own view is that the fell deed was done unconsciously and from the highest motives by certain amiable gentlemen in the last century.

If any one wants to get some measure of the harm the Gothic Revival did and still does to our towns and villages let him visit the cities of northern Italy. There he will see how the classical tradition of simple rectangular buildings, with regularly spaced windows and low-pitched roofs, still controls all vernacular building. He will see everywhere dwelling-houses, farm-houses, factories, both new and old, which in their unaffected dignity, simplicity and repose might be the work of our own Sir Edwin Lutyens in his latest manner. Motoring across the Lombardy Plain or in the train through the hills of Tuscany one is always coming across another Lutyens house. One continually sees the buildings of Smith Square surrounded by vineyards, solid square blocks with widely and evenly spaced windows and plenty of plain wall surface. Americans in Italy must similarly have found numerous examples of the work of their great domestic architect Charles A. Platt.

Now in the eighteenth century we in England were building in the same Italian way. The square Queen Anne and Georgian houses with their regular windows and low roofs, which line the high streets of our country towns or stand as independent units surrounded with their walled gardens, are the exact counterpart of similar Italian buildings, allowing for differences in materials, such as universal stucco and pantiles in Italy and brick and generally slate or plain tiles with us, though sometimes, particularly in London, we used pantiles, too. These simple buildings, whether large or small, as one can see in Italy, always composed satisfactorily one with the other. Such buildings never jar with one another or with the landscape.

Outside Milan, a town which in size and business life compares with Manchester or Leeds, there is no rash of ugly little squiff-eyed villas with perky roofs, irregular windows and ugly projections in front and rear. Everywhere there are these simple cubical structures with regular windows, plastered and roofed as has been the tradition for centuries. Even in the

centre of Milan, after walking about the town for a week, I could find only one irregular aggressive modern structure. I certainly did not find many good modern buildings, but—and this is much more important to the town as a whole—the masses of bad ones which we seem in England to take for granted were not there.

Now if the Gothic Revival had not broken up the classical tradition with us, should we still be building in town, suburb and country in the same simple way? I venture to think we should. It is appalling therefore to imagine the infinite damage that that movement of earnest but archæologically-minded men has done for us and our inheritance. We pride ourselves as a nation on our strong conservatism and common sense, but in truth we are more sentimental, more easily swept away by romantic highfalutin than any other race except the purely Teutonic ones. Ruskin simply turned us, or rather our houses, upside down. The quiet dignified old England of Rowlandson's drawings—I refer to the houses not to the people—was changed to the speckled red and white, the pink and blue irregularly strewn crumbs of any awkward pointed shape of which Bournemouth, wholly built in Ruskinian and post-Ruskinian times, provides the supreme example.

We may laugh at modern Italian painting or cry when we compare it with the old, we may sneer at the dexterity which produces endless alabaster figures of girls in tight-fitting bathing costumes or of sentimental cupids, though we should remember that they are mostly made for the English market; but we cannot afford to look down on ordinary modern Italian building, free as it is from all eccentricity and strong as it is in its traditional way. Noticing the same good shapes and proportions everywhere in town and country alike, we see it is a real vernacular form of expression. It must be the work of folk who do it largely, if not entirely, instinctively. I doubt whether in most cases architects are employed at all. If they are, they must be almost celestial architects who are willing for the public good to sink their personalities and eccentricities in a way unknown to us.

To my argument that it was the Gothic Revival that did the damage and set us all on the wrong track, some may reply that Italian towns like Siena are full of real Gothic palaces, and yet they compose perfectly and their streets provide more beautiful scenes than any others. To this I would answer that the Italian Gothic palaces may have been built during the Gothic period, and are indeed full of Gothic detail, but they are not Gothic in spirit. They are rectangular in shape without any excrescences, bay windows and pointed roofs which show, just as the Gothic Towers of St. Gemignano are all rectangular. Gothic in Italy was never more than skin deep and was never revived as a semi-religious, semi-sociological exercise.

When Italy wanted to let off steam and be romantic and exciting, as all live folk do every now and then, she invented the baroque, and a very splendid invention it was for the purpose. How much better to swagger and pose a little with some invention of your own than to fiddle about with monkish ideas five centuries old and standing for a completely different outlook on life. Anyhow the baroque never interfered with the peasants' or citizens' dwellings, never turned the house of the clerk from a quietly beautiful cottage into the little suburban English villa as did our own revived Gothic.

XI.

ARCHITECTURE AND YOUTH.

THE technique of building is too complicated to allow a young man of genius to plunge into it with success unless he is specially placed to receive expert assistance. When to the technique of mere building one adds, as one must, the technique of some form of architectural expression, Classic, Gothic, Renaissance, or whatever it may be as the formula on which to base his method of design, one realises that the young architect has a long way to go before he can find himself, apart altogether from the question of obtaining commissions. The period of five years' training laid down in the recognized Schools of Architecture as a minimum, barely suffices to give him freedom from these technical difficulties. If he is an articled pupil, content to work in the manner of his master, he may no doubt achieve an imitation of that manner in a shorter time. The building and the architectural technique, however, which he will have learnt will be merely that of his master's particular type of building and design. If he means so to limit his range that may suffice, though with changing materials and new conditions of building something wider is obviously desirable. In the days of a settled tradition or style, part of the problem was already solved for the young designer. In no way else can one explain how a young man like John Wood could have come down from the wilds of Yorkshire and at twenty-one have designed and carried out his first, yet thoroughly mature, terraces of houses at Bath. The orders of architecture were to his hand as well as a recognised method of planning and composition, and he, like most of the 18th century architects, appears to have had little or none of the modern desire for individual expression. His originality consisted in the breadth and boldness of his schemes for his adopted city rather than in a personal outlook on his art.

The great example of the apparently untrained architect, who immediately succeeded, is Sir John Vanbrugh who built Blenheim Palace, Castle Howard, and a dozen other great mansions, and eventually almost rivalled Sir Christopher Wren himself in the extent of his practice. He appears at first sight to jump into the profession of architect from that of dramatist without any preparation at all. Here, too, was a man with a very distinct individuality, whose buildings show it at every turn. The conditions under which 18th century architects worked, however, were very different from those of to-day. Vanbrugh, in connection with his own plays, may have made rough drafts for the scenery. It was hardly more than such that

he needed to make for his buildings in the first instance. The complicated and exact modern working drawings, sufficient to form the basis of a contract which will stand in law, were unknown in his days. Tradesmen were accustomed to tender on very slight indications on paper of what was required. The general style of the time would be known. A gentleman's mansion was built in such and such a way, with such and such thicknesses of walls and finishings. However, this is not enough to explain Vanbrugh. The explanation in his case is the devoted assistant architect, Nicholas Hawksmoor. Wren's scholar and friend not only carried out many of Wren's own buildings for him, but was regularly employed by Vanbrugh. Vanbrugh was the man about town, who obtained the commissions and provided first schemes, and later on, no doubt, some of the detail drawings; but Hawksmoor was the man who surmounted the constructional difficulties and saw the work to completion, supplying a great many details himself.

So it is to-day. If a man of genius like Sir Giles Gilbert Scott wins at the age of twenty-one a competition for a great cathedral, as at Liverpool, it is because he has already at his command, through family atmosphere and association as well as through his apprenticeship to a Gothic architect, the technique of Gothic architecture. Being a man of genius he can, during the slow building of the cathedral, not only learn building technique but develop his own form of Gothic expression. How great a development Scott has made in this way during the twenty years Liverpool Cathedral has been in course of erection, everyone who has seen it knows. How little experience he had of actual building when he obtained the prize, we know from his own words. When asked by a Liverpool newspaper reporter what he had built, he says he could only think of a pipe rack for which he had made a drawing, and even that was carried out by his sister with a fretsaw. His competition drawings, however, show that, from his master and from his study of Gothic work, he had already a very fair idea of the size of piers and buttresses he should use both for appearance and for strength. The rest he must have learnt as he went along—a good deal no doubt on the construction side from his first five years' collaboration with Mr. Bodley.

Scott, though, is an exceptional case. It would be very foolish for the aspiring young architect to feel he could do with as little training, even if he has been brought up in the atmosphere of a style as Scott was. Besides, to-day he would probably have but little desire to build in any exact tradition. He would rightly be ambitious, like Scott, to give a modern meaning to his work. To do this successfully, however, does not mean that the young architect need not know and study the old work. Rather he must study it all the more to see what is essential in it, and what merely transient and belonging to its own era. In any case he cannot do without an alphabet.

Certain things he will have to use to gain any expression at all, that is, unless he desires to erect but a purely engineering structure. He is sure to wish that his building should make not only an emphatic appeal to the imagination, but should have certain delicacies and refinements, that it should conjure up in the beholder certain associated ideas. To obtain such things however in a non-copying, non-traditional way implies more knowledge of the past, not less. It means much measuring of old work, much studying of proportions, both in plan and section as well as in elevation.

If, however, the young architect, to equip himself, must go through many years of strenuous training, when that has been accomplished, a glorious field of effort faces him. He will have learnt the rudiments of an art in which any work, however small, is delightful labour. To design a cottage successfully is a very happy exercise. Every piece of work which comes to hand gives scope for thought and feeling. Thought alone is not enough. That is the great charm of architecture. By thought an engineer works, an architect by thought and feeling combined. An architect may not become a rich man—he very seldom does—but, if he has the roots of the matter in him, he can never become a dull one.

Then there is always the gamble of the great competition. In no other profession can youth jump so readily to the great opportunity if he cares to try. Admittedly it is a gamble, for assessors and judges are very imperfect human beings, especially when working singly with no opposing idiosyncrasies to cancel one another. Still the great gamble sometimes comes off. E. A. Rickards was only twenty when, working with his partners, his design won the great Town Hall and Law Courts buildings at Cardiff, which for twenty-five years or more have proved themselves good and beautiful buildings as well as a winning design—not by any means, or even generally, the same thing. At twenty-eight Mr. Ralph Knott won the competition for the great London County Hall. But I do not want to dwell on the winning of competitions as the end or beginning of an architect's career. They are the spectacular successes, but it must be confessed that very few of them have fallen to the architects who are by consent the leading artists in their profession. No, the pleasures of architecture must be the end in themselves, and to the young man who, having the right equipment, seeks them earnestly as his life's work, there is no limit to the pleasure and interest his life will afford him.

XII.

COLOUR IN STREET ARCHITECTURE.

THE question is always being asked why cannot we have more colour in our town buildings, and the makers of glazed tiles and terra-cotta are always replying than we can if only we would. The people, however, who seem most ready to accept definitely the invitation are the owners of kinemas and public-houses. Here, then, is a mystery; on the one hand a sincere desire for a brighter and richer architecture, and on the other the chief response from those whose business it is to satisfy only the very simplest desires and emotions.

The first question to answer is, What do we mean and hope by the word "colour"? Do we mean by it masses of elementary reds, greens, blues, and yellows, or do we mean the rich and varied tones of broken colour? If we mean the latter, and some would find in it more "colour" than in the former, the broken surface of old brickwork, the pearly greys, the rich browns and yellows of stone provide it in abundance. But if by colour we mean large solid surfaces of strong primary colours, we ought at once to pay tribute to the efforts of the publicans who, wittingly or otherwise, have in this matter been pioneers, unsung if not entirely unrewarded.

Before we proceed, however, to spread, as with a palette knife, stretches of primary colours on our street fronts, let us look at the whole canvas before us. A good third of the surface in any street scene, and more at the intersections of streets, must be given up to sky. What is its tone? Three days out of four a dull grey, and on the fourth at most a pale blue. Our masses of solid colour have, then, to be seen against a low-toned background. That is the really important factor. It is in this that our street scene differs from one in Monte Carlo, ancient Athens, or Thebes. In the brightness of the Mediterranean sun a white building, even a stone or marble one, dazzles the eye so that its form cannot be read. Colour is, therefore, necessary and agreeable, and, as everyone knows, it was used in classical times in all its primary strength. The famous frieze of low relief carving of the Parthenon was not only coloured but placed under the shadow of the deep peristyle behind a row of columns so that it might be read by light reflected from the ground. This was the only way in which its full value could be appreciated. Hence, too, the enrichment of the underside of cornices rather than of their face. When a Liverpool or Manchester sky throws down so little direct light, how much rises from a Liverpool or Manchester street? The problem, therefore, in our northern

greyer latitude, of what is the happy tone of colour for our buildings (apart from the aggravation of dirt and smoke, as the country town witnesses) is altogether different. Masses of solid colour, which under a bright sky look gay and happy, with us become heavy and crude. One has only to recall the dismal entrances to the Tube railway stations in London to see that solid colours, far from having a refreshing effect, have with us just the reverse. It may be argued that the crudity would go, or at any rate be less, if the whole street were in bright primary hues. At present, among ordinary stone and brick buildings, the brightly glazed coloured building is like an enamelled iron sign on an old wall. If the whole wall were enamelled, however, there would still be the contrast with the surface of the street, unless that were enamelled too, and with the sky, which no form of sky-writing has yet been able to turn into Prussian blue and vermilion.

The quality of the colour which the ancients used on their buildings, when it was applied colour and not that of the natural material, marble, brick, or stone, was not the quality we are invited to use to-day. As far as can be judged from fragments, the quality of the colour on a Greek building was more like that of thin water-colour than thick oil colour, whereas the glazed materials of to-day are far more treacly than oil paint. Look at the glazed portions of the Midland Hotel, Manchester. They have a solid glueyness, a thick, uniform viscosity which is the very negation of life and colour. Natural materials, though they may very quickly become darker and duller in Manchester air, never become so dead as these artificial ones. The latter may indeed be washed—unwashed they hold the dirt in streaks and patches in a much less pleasant way than natural ones,—but they cannot be brought back to life, for they have never really lived. They were cast in moulds from the start, and were repeated endlessly. In the baking, too, they twisted not a little, so that there is always an uneven puffiness of surface and line. They have not the clean-cut look of stone from the chisel, or even of brickwork truly laid. It is a case of cast material in place of wrought, and of a cast material which does not cast well. This, of course, only applies to glazed and unglazed terra-cotta when used structurally to take the place of brick or stone. It is quite another thing when it is used decoratively, as the Delia Robbias used it, inset in brick, stone, or plaster. Its very irregularities then increase its decorative value. These objections, too, would not, in my mind, apply with quite the same force to a purely surface material like tiles or mosaic. The difficulty of the bright colouring against the dull sky would, of course, be there, but from the multiplicity of joints and surfaces the colour would be less solid, more broken in fact. In Portugal there are houses faced with coloured tiles which give a pleasant effect, but there again the latitude and atmosphere are different. We have yet to see a satisfactory external use of glazed materials in this country. When it does come, about which I am very doubtful, it must for good

neighbourly reasons be applied to a whole street or district at once. Isolated patches like public-house fronts and Tube railway stations do the same sort of violence to adjacent buildings in natural materials that an enamelled iron sign does to a country lane when set up in a field alongside.

XIII.

EVERYDAY ARCHITECTURE.

IF we were all fortunate enough to live in the few unspoilt English villages or country towns that are left, or if we occupied an apartment in Park-avenue or Fifth avenue, New York, or in the central part of Paris, not to mention rooms in a palace in one of the hill towns of Italy, we would understand without more ado that architecture is an everyday affair. As it is, living in Liverpool or Manchester or in a London suburb, we think of architecture, if we think of it at all, as an affair of big buildings, town halls and cathedrals, and probably now and then of banks and insurance offices. Even so, it is a mystery which a few highbrow people know all about and no one else can understand. This, of course, does not prevent us from enjoying the old villages and towns we motor through. We have long learnt, indeed, that they provide the chief interest in motoring. But that they are architecture, and that each of the little buildings we see nestling together has been consciously designed by someone, even if that someone did not call himself an architect, never occurs to us. And perhaps rightly. We are so accustomed to connect the word architecture and the man architect with our ugly over-emphasised town buildings that these modest little country ones are obviously something else. We assume that, like the trees or like Topsy, they just grew.

Herein lies a complete fallacy, which is nothing less than a tragedy. The cottages and little shops we have liked so much in our country visits, without quite knowing why, have all been the cousins, once or twice removed, of the squire's mansion. The little village church has borne the same relationship to the cathedral in the neighbouring town. Now we know that the cathedral and the mansion house are architecture. I am afraid, therefore, that we must admit that the others are architecture too. If so, we shall come to this strange conclusion, that in the days when things were beautiful they were all architecture. Architecture indeed was an everyday thing. We might even go further and say when it ceased to be an everyday thing, when it was reserved for some theatrical make-believe, and became thereby divorced from life, it ceased to be architecture. That is why the architect should be one of the most important persons in the State, why he should be trained as for a priesthood, and when trained why he should be trusted, why indeed the whole external form of the material side of our civilisation should be moulded by him. He, and he alone, if he is properly

endowed and properly trusted, has the means to make our towns beautiful again.

If our architects, however, are to be trained as priests, standing between God and the people, the life they interpret in brick and stone must be something very different from the sordid materialistic life which has followed the industrial revolution. These old villages and towns we liked were all antecedent to that revolution, and the life they interpreted, to which they still bear witness, was something very different from Victorian self-righteousness or Edwardian money-making. These latter showed themselves very plainly in the architecture they brought about. I suppose there has been no such vulgar period in our whole architectural history as the last fifty years. Individualism ran riot; restraint of every kind gave way, and our town buildings became the be-columned and be-swagged, the overdressed and under-mannered structures we know so well. Our suburbs became either the endless rows of little grinning puppy-like villas of the poor or the be-gabled flaunting sham half-timbered pressed-brick houses of the rich. And the richer we got the worse our buildings became.

Now, thank God, we are all poor again, and what do we find? Everywhere arising a leaner and cleaner architecture. The Government housing schemes, whatever they have cost (and it is only fair to say that in the majority of cases the excessive cost has not been inherent in the design), show once more the simple cottage buildings of our travels, or rather ones which exhibit an obvious relation to them. Everyone must have been struck with the new everyday architecture which has grown up on the outskirts of all our towns. Architecture and architects have been brought back to the workman's cottage. As the workman suffered most by her neglect in the past, so rightly he is first to welcome her return. I have not yet noticed that architecture has spread to any great extent to the £1,500-£2,000 house, except in a few favoured spots. But the owner of such a house can demand her services if he wants them. He may, of course, still belong to the pre-war years of vulgar display. Some folk never learn, even by a European war. The new, lean, straightforward architecture of our own day, with no fly-blown philacteries of dead ornament, is growing nevertheless. It is to be seen already in several of our bigger new buildings. There was a beginning of it in the cliff-like walls of the Adelphi and Cunard buildings, in Liverpool, before the war. The great plain wall surfaces of the Bush building in the Strand, with their even distribution of windows, giving expression to the building's total mass rather than to any individual feature, are in the new manner. So is the fine stark massive block the Ministry of Pensions has put up at Acton. So will be the new Holt building, Liverpool, when erected. All these, like the new Government cottages, so similar to one another in shape, express the increasingly communal aspect of modern

life. Strict economy and steel construction in the case of the big buildings, strict economy and an appreciation of the value of light and air in the case of the small buildings, have together led to simpler, cleaner, more direct structures than our wealthy late Victorian and Edwardian predecessors could dream of, much less desire. May the demand for the new architecture continue to grow, and may the Schools of Architecture prove worthy of the great mission which lies before them!

XIV.

MODERN AMERICAN ARCHITECTURE.

IN the series of delightful letters Rupert Brooke sent from the States to the old *Westminster Gazette* before the war, he placed among America's five great achievements her modern architecture. Anyone who has visited America recently will realise that if magnificent modern architecture eight or ten years ago was one of the five finest things she had produced, this architecture has now probably reached the first place. It is very doubtful whether anything like this could be said of any other country, and certainly not of our own. With us, the last fifty years have hardly formed a great architectural epoch. This period may have been distinguished in literature, both in prose and poetry, but certainly not in the plastic arts, and least so in architecture. The last twenty have no doubt seen an advance and the last ten a proportionately greater one. The revived interest, first in old furniture and then in old buildings, which has been so remarkable a feature of these years has begun to react on our new buildings. Clients, again, have taste and are beginning to exact it from their architects in even greater measure. But any advance we have made has been nothing to that made by our so-called transatlantic cousins. Their advance in the oldest and noblest of the arts has not only been relatively greater than ours, but their absolute achievement has been immeasurably greater too. Starting with less good old work at their side—they had little more than their wooden colonial houses—they have far outstripped us in the general quality of their new. I say the general quality, for, of course, we have not been entirely without our modern architects, who as artists have upheld our ancient faculty of building beautifully, but unfortunately such artists have been the exception. No one who walks through the City of London, or along Oxford Street or New Regent Street, could maintain that the mass of our modern town buildings compares with the few old ones like Somerset House, or such of Nash's plaster palaces as still remain to serve as a standard. On the other hand, anyone who walks down Fifth Avenue from, say, 30th Street to 70th Street passes block after block of buildings all modern and mostly built during the last twenty years, a great number of which are comparable in charm with the Italian and French palaces which have distantly inspired them. They have the same dignity and reserve which seems to be a distinguishing characteristic of most eras but our own. They are scholarly buildings too, in that there is little detail in them to worry the connoisseur in the way in which some sudden break in the line of a modern piece of furniture worries those who know the old. If the general idea of a Florentine palace is used

for the façades of a modern building, as in University Club, it is used thoroughly and with knowledge; the small refinements of contrasting textures and mouldings, the massive bulk and cliff-like walls which go to make up the charm of the original finding their echo in the modern building. The building is not Florentine in the basement, Milanese in the middle stories, and Venetian at the top. I should say that the distinguishing note of modern American architecture is its scholarship. Thirty years ago some of these new buildings appeared to the general public to be almost copies of famous European ones, and the great American architect, McKim, justified this by saying that as their continent lacked the foundation of fine old buildings, such as we have got, on which to found their new, he was ready to import them. But in so saying he did himself an injustice, for his buildings, such as Tiffany's, which are nearest to being copies of palaces in the old world, are really very far from it; while his last and those of his successors are faithful only to the spirit of the style in which they are built and not to the letter. Have not some of our own best modern buildings been produced in this way, such as the Reform Club in Pall Mall, which is based quite obviously on the Farnese Palace in Rome, but with a smaller scale to suit the smaller scale of our streets and buildings?

Apart from this question of inspiration, what are the things in American buildings in general which strike the Englishman when he first sees New York, Washington, or any of the larger Eastern Cities? I think the very first thing is their apparent solidity and simplicity. They seem made up of a few large parts rather than infinite numbers of small parts. If columns are used they are used boldly as in the Lincoln Memorial or the Temple of the Scottish rite at Washington, and are, as they should be, dominating features. If we look, too, at the general mass of an American building, we see that it is usually of some simple shape such as a rectangular mass crowned by another rectangular mass or a cube crowned by a truncated pyramid. Towers, gables, small domes, such as those with which we are accustomed to ornament so many of our buildings, are largely absent. The dome, when it is used, is used nobly to express some great central civic or governmental building like the Capitol of the State; indeed, in America the dome raised on a drum has almost come to signify this and nothing else, just as in Italy and France it was chiefly used to express the cathedral or cathedral-like church. This simplicity of mass which is so necessary, if a building is to make a strong impact on the imagination when first seen, is no doubt helped by the rectangular sites on which most American buildings are built. The scheme of cutting up the town area into rectangles by streets and avenues crossing one another at right angles, while it often leads to monotonous streets which appear to go on endlessly and have no proper beginning or end, means, however, that most buildings of any size either

occupy a whole town block or have a return face on the cross street. This at once gives them a solidity of appearance which buildings with only one front to a street can never have. You notice this particularly when you first arrive in New York at the Great Central Station, itself a terminus on a scale of which we have not yet dreamt. You step out into 42nd Street and are surrounded on all sides by great creamy grey masses of building which are shooting up into the sky all round you. They are the great new hotels and apartment houses, a fresh one of which arises every few months in this district. They seem like great solid cliffs of stone and brick which have been cut with a knife into huge, simple rectangular blocks. If they were of any fussy shape or covered with turrets and gables they would be a nightmare. As it is, when once one has got over the strangeness of their size, one finds them very dignified. The streets which form the spaces between the blocks are sufficiently wide for the sun to light up one face, leaving the other in shadow, so that the full effect of their volume, as the cubist painter would say, is felt. In these cases, all the architect has to do is to emphasize their shape by decorating a group of storeys at the ground floor level to form a base to his wall, and another group at the top to form a coping leaving the middle portion plain and allowing the endless windows in it to give texture very much as the bricks with their mortar joints when properly built do with us. These hotel blocks, though, are perhaps an extreme example of simple masses. The best high buildings, however, follow the same scheme, only in this case the rectangle is stretched upwards till it becomes a square tower or campanile. When so treated and when it is well separated from other high buildings, the so-called skyscraper is a thing of great beauty. As an isolated shaft of white marble running up four or five hundred feet into the air and crowned at the top with marble balconies and pyramidical roof, like the campanile of St. Mark's at Venice, it becomes a thing of intense and delicate beauty. Such a marble tower is that of the office of the Metropolitan Life Insurance Company in Madison Square, which alike by day and night, for it is lit up at night with floods of electric light, is a romantic and wonderful object to all the central up-town district. The high buildings at the foot of the island, while they form, as seen from the river, one of the most thrillingly romantic sights in the world, outdoing anything Albert Dürer ever imagined, spoil each other when you see them close at hand by their proximity to one another. They become a confused mass of buildings, very much in the way a series of office façades do in the City of London, only here they add to the tangle a variety of heights. The obvious lesson is that if we are to adopt in England the high building, which has spread now to many other towns in America besides New York, and to some in Canada too, we should insist that where once one high building has been built no other shall be built within a radius of, say, a quarter of a mile. In this way our modern business towns would be enlivened with a

series of towers which would catch the eye in all directions, closing vistas and displacing monotony with romance, while light and air would still circulate.

Washington is a city which is not burdened with the complete square gridiron plan of other American cities. It is built on the fine scheme of a French 18th century architect and engineer, named L'Enfant, and has a number of diagonal streets radiating from the Capitol and other important points. The result is that in addition to the square blocks facing the main streets it has many terminal sites on which great public buildings have been placed, where they can be seen dominating and closing one or more vistas. Its streets therefore do not wander on endlessly and aimlessly, but lead from the Capitol to White House or to the Congressional Library—one of the worst buildings in America—or to the Great Union Railway Station into which, by a modern improvement, all railway lines converge. It has, too, the famous Mall, a stretch of grass and trees many hundred feet wide and a couple of miles long, leading from the Capitol past the great stark obelisk to Washington—the finest and simplest monument in the world— to the Greek Doric Hall recently erected in memory of Lincoln, in which the refinements of Greek marble architecture live again. Washington, however, is a special city and its buildings are largely Governmental buildings. In that sense it is not so typical of American architecture as New York, Chicago, or half a dozen other places. One may confess that one gets a little tired of its colonnaded splendours, though it contains one or two of the most striking modern classical buildings in the world, such as John Russell Pope's great and dramatic pile for the Masons of the Scottish rite, and Paul Cret's delicate jewel-like building for the South American Republics.

The same note of simplicity and directness, which is the general characteristic of the best American buildings in mass and exterior, is also to be seen in their interiors. A great bank or commercial house does not have for its accommodation, as so often in England, a series of small rooms more or less cut off from one another with what is little more than a waiting space for the public. Instead there is a great open hall in which is apparently carried on the whole business of the company. Across a sea of clerks' heads you can make out in the distance, only separated from the herd, if at all, by low glass partitions, the president, the vice-presidents, and the managers of departments. The result is that a banking hall, for such it is now called, becomes a great architectural opportunity, which the leading American architects have been eager to seize upon. But here again the architecture is reserved and simple if of costly materials. As in their great railway termini, where no advertisement posters are allowed, the bankers and the business men generally have realised that a fine and dignified

building is in itself the best advertisement. We are still too content in England, I think, to carry out our day's work in office-rooms to which we would not condemn our servants in our own homes. Perhaps it is some relic of Puritanism, though I fancy it has more to do with Victorian self-righteousness, that we seem to take a pride as a nation in working in uncomfortable conditions. The American on the other hand will live in a wooden shack or a tiny apartment, but will expect the office, where he carries out his life's work and spends most of his waking hours, to express in some way the dignity of his labour. There is a good deal, obviously, to be said for his point of view. At any rate, it is one which appeals to his architect, with the result that we do not find in America the architectural profession divided into artists who build houses and surveyors who build offices, as it might roughly be said to be divided in England. The American architect feels, as no doubt his English confrère does, that all good building is within his province; but he differs in this, that over there the best men seem to get the best of every kind of work to do whether it be ecclesiastical, commercial or domestic, and by their training, when they get it, seem equal to carrying it out.

After all, however, it is not the opportunities either of site or money which make great architecture, but the men who design it. How is it that the men who create the buildings of America are, on the whole, more successful in their bigger creations than the men over here? No one can say of the heterogeneous mass of undigested nationalities, which at present makes up the great United States, that, like the Greeks of old, they are a race of artists. Neither in literature nor in painting have they had the success they have gained in architecture and are beginning to gain in sculpture. The explanation can only be in the organisation of their work, and in that term I would include both their methods of attacking problems as well as their methods of training. Let us take their methods of attack first. The designing of buildings in America like most things on that continent seems to gain in efficiency when done on a large scale. The office of an American architect, when in fair practice, is a very different affair to the office of a similarly placed English architect. Fifty to a hundred assistants are no rare thing, while in most of the big designing groups there are anything up to half a dozen partners, or, if not so many partners, there are fully fledged architects who have seats in the office using the office machine, and in return giving their criticism and assistance when called upon. This and the fact that in the end everything down to the position of a bell-push has to be shown on American working drawings, owing to the absence of the subsidiary profession of quantity surveyors which we have in England with their strange skill in measuring alterations from the original drawings, leads to a much greater preliminary study of the building both as a whole and in detail than is possible to the English architect often working

single-handed or with a couple of assistants. Contrary to what one might imagine the American architect by his training does not allow himself to be hustled by his client into making up his mind prematurely, neither does he in his turn hustle his assistants. He insists on keeping his design in a fluid state, where everything can be altered, till he is thoroughly satisfied that he has obtained the right solution to the problem. To assist him in this he has not only the criticism of his partners and assistants, but such a library of the world's architecture as can rarely be seen in a reference library in England. Where the English architect, till recently, was content with a few photographs and plates from illustrated papers, relying on his invention for everything else, the American architect is sufficiently a scholar in his art to desire to know before he starts his drawings the best solutions to his particular problem the world has to offer. In fact, he feels as an American architect he is the rightful heir to the world's architecture, and in his work he expresses this. When he wants to be stately and imposing, as in his great railway stations, he is Roman in his architecture; when he wants to express scholarship and refinement, as in his art galleries and museums, he is Greek or Italian; and when it is merely the domestic virtues or comforts he is dealing with, he turns for inspiration to Italian, Spanish, or Georgian prototypes. This may not be the way to produce great architecture—it obviously is not—but it produces buildings which, if inoffensive and polite as individuals, in the mass make suave and elegant cities.

In his training, too, the American architect's methods have, till the last fifteen years, equally differed from our own. Firstly, I suppose, because the profession is a much more lucrative one in America with its larger commissions and more expensive buildings than it is with us, the American architect has been willing to spend more money on his specialised education. More than twenty years ago he gave up the method of apprenticeship which has come down to us from medieval times and still lingers among us. Instead he has followed the French in their system of architectural schools. These schools are now attached to all the leading Universities, with four-year courses supplemented in many cases with other scholastic work in Paris and Rome. In England some of our Universities have started schools of architecture too. There is also the school in London founded by the younger professional body of architects, but so far these schools have not had time to influence current architecture to the extent that the American ones have done. The mass of practising English architects are still office-trained men with the specialised and sometimes narrow outlook on their art, which they have gained from the master under whom they served their apprenticeship. The result is often charming individual work, especially in domestic building where the problems to be faced are not of so generalised a character. But the slightly eccentric and original solution, which may be pleasant enough in a small country house,

becomes an absurdity in a bank or a municipal building. In such work the general restraint which knowledge brings is more valuable than the happy inventions of the individual designer. In our town architecture we have long suffered from an excess of originality. In the days when there was a generally accepted tradition, faith in that tradition prevented such blunders. The days of faith in architecture are past. Unless we are to be content with ignorance in our buildings knowledge must take its place. In the great complexity of detailed knowledge required to make a large modern building the minds of many men must be united. In that direction lies efficiency in its broadest sense, and in that sense efficiency is beauty. It therefore seems to me likely that in future we shall revert again to something like the conditions under which the great Gothic Cathedrals were built, when the architect, as an individual, was content to sink himself in the greatness of his work. He lost his soul to find it in his building. Perhaps the root explanation is that in England our architects have been a little too anxious about their souls and the expression due to them, while in America their architects have been thinking mainly of the greatness of the work they are called on to carry out.

XV.

THE CHOICE OF A SMALL COUNTRY HOUSE.

CHOOSING a small country house by the man of average means who can afford one at all is like choosing a wife. You may lay down beforehand all kinds of rules you mean to follow—that the lady of your choice will be blonde and fair, with a placid, broad outlook on life, and you will almost certainly marry a sparkling brunette, quick, lively and sympathetic. So with a house. You may think your ideal is some rambling converted or convertible farmhouse, some picturesque Elizabethan or Jacobean manor house, and you will end with the primmest of Georgian proprieties, facing a village green or country high street, but with a large walled garden behind, where you can be as private and irregular as you like. You may think open raftered rooms with bare brick chimneypieces, where you can stalk about in rough country clothes, the thing you are in search of, and then you, or more probably your wife, will fall to some set of spacious, sunlit, white-panelled Queen Anne or Georgian chambers, looking out over trim lawns and well kept hedges. Or you may find something that does not fall into either category, picturesque or formal, but by a combination of both absolutely bewitches you and drives all preconceived ideas to the winds; indeed, a house of this kind generally does unless you are an absolute formalist and pedant. There is something so very lovable in the marks of time, not only the minor ones, such as floors slightly out of level, cornices softened with the colour-washes of generations, but the major ones which represent distinct past eras. The Jacobean house which has had parts of it Georgianised carries with it the same history with which we ourselves have been built up. It has, perhaps, its central hall with stone floor and oak beams and great chimney-piece with rude carving over it, answering to the rougher barbaric instincts which are deep in all of us; and it has its Georgian rooms with their refined cornices and fireplaces and long elegant windows calling for curtains of brocade or other fine material. In these latter we can cast aside our thick boots and tweeds and become civilised, urbane and even slightly cynical. In such a house, therefore, we have rooms for various moods, corresponding not only to the strata of our external civilisation but to the strata within us. In some modern houses such things have been consciously attempted, but their failure is generally complete. You may wear fancy dress for a night, but you cannot, if you are an ordinary mortal, endure it for a week. Affected age in a modern house is something of that sort, and it becomes worse when it is an affectation not of one age, but of several. No, a modern house needs unity; our

grandchildren are the only people who can break that unity successfully, because they will break in answer to some new and real need not yet experienced by us.

Let us assume in this search for a small country house that it is no marriage of convenience we desire. We are not tied, that is to say, to a railway station, but with the help of a small car can reach a convenient line when we want to go to town or to fetch our friends. Obviously, the advent of the motor car has enormously increased the area of our choice. We can now live in real country even if we have to go to town four or five times a week. If London is our centre, we can get as far afield as the Cotswolds, South Downs or the remoter parts of Essex. We can therefore let our choice of a house range over modelled stone houses, warm brick ones or those of wood and plaster. We may even, if we are particularly interested in refined proportions, restraint and elegance of detail, consider Regency and early Victorian stucco. In this latter case, however, we must be prepared for a quinquennial paint bill, but we shall have other compensations, not least in the original price, for such houses are not yet popular. It will be noticed that I am ruling out of our purview all absolutely modern houses, say, those of the last sixty years or so. The reason is that you cannot generalise about such buildings. You may find one to fit your individual taste just as well as if you had instructed your architect to design it. But the chances are against it for many reasons, chief among which is that the last half-century has been a time of excessive individualism. To find, therefore, an entirely satisfactory modern house that will not only fit your material needs, but satisfy your spiritual ones too,—which is a much more difficult but far more important matter for real happiness—is highly improbable. I do not mean to say that there are not hundreds of beautiful modern houses by Lutyens, Newton, Norman Shaw and their followers, but each was designed for a particular client and in a particular way, which older houses, as far as we can tell, were not. In the days of a solid architectural tradition there were certain methods of planning, certain methods of decoration from which no one thought of departing. After the entire break-up of such traditions in the middle of last century even the best architects and their clients sought for individual solutions to problems and individual methods of expression. Those who did not went on building the coarse Victorian houses we see in all our suburbs. Obviously, these are out of the question. One would sooner not live in the country at all than live in a suburban country house, thereby preserving a blot on the countryside. But to return to the good modern country house built by a good architect. You may say, Why not buy that? What could be better? The construction is probably sound, the drains and water supply all good, and the roof not likely to be a source of expense for upkeep. I can only reply by comparing such a house with other people's clothes. You might find a suit of someone else's, or a

ready-made one, which absolutely fitted you. It is unlikely; but, even if you did, you would be wearing borrowed plumes. Your distinction—and with a modern house, built for someone else, you could not escape a certain prominence—would be that someone else's. With an old house, however modernised in its unessentials—unessential except from the housewife's point of view—you make no pretence that you are more than a life tenant. You are merely the custodian and preserver of a beautiful thing you intend to hand on in the same or in a better state than you received it. Build a beautiful modern house by all means, and by so doing add to the real wealth of the nation. That is a very different proposition. Do it, though, with humility, as a man chooses a suit, not as a woman chooses a dress. Make it something reserved and quiet, answering not only to your special needs, but to the general ones of our time. Make it fit the landscape and adhere to the type of building traditional to the countryside. Do not introduce brick and tiles into a stone and slate neighbourhood, or *vice versa*. If you do, you will probably have to pay for your rashness in hard cash. I know a neighbourhood in Essex where in the heat of the summer all the modern brick buildings on the shrinking clay soil crack, whereas the old wood and plaster ones float on the moving ground like ships and remain intact.

If you are about to buy an old house, however, there are certain points, rather obvious perhaps, which may be worth recalling.

First there is the question of the site, and in this, of course, one has not the same freedom of choice as in a new house. For one thing, our ancestors especially those who lived before the romantic movement, had not the desire for extensive views from their windows that is characteristic of to-day. The sites they chose were usually sheltered ones, often in positive hollows. No doubt, access to roads, themselves less numerous than now, had something to do with this, but it was a question of temperament too. In Georgian times for the smaller houses they seemed to prefer seclusion and privacy on one side of the house even when they made a bold front to the road or village green on the other. I suppose if they wanted a view they climbed a neighbouring hill to get it. There is something, I think, to be said for this, especially if the view is over the sea or a wide estuary. Such a view continually before the eyes is apt to be depressing. A wide view is all very well in a holiday resort as a contrast to the shelter of one's walled garden at home. To live on the mountain tops all the time, however, is too strenuous for most mortals. We are not all poets and seers who can look eternity in the face every hour of the day. There may, therefore, have been a certain wisdom in the builders of old houses in sheltered situations, an intuitive knowledge of psychology if not of hygiene. This being so, it is all the more necessary to make sure, not only that the house is dry or can be made so,

but that the site itself does not exhale vapours. It is not pleasant when November comes to find each night and morning the chimneys of one's house poking out of a cloud of mist while the rising ground on either side is free. Such mists, however, are not generally to be found above a chalk or gravel soil unless they come from the sea. With clay and loam the matter is different, and it is well, then, to make further enquiries if the house of one's desire happens to be in a hollow.

The dryness of the structure is a different matter. Most old houses were built without damp-proof courses—I think an early nineteenth-century invention. These are layers of slates and cement or asphalt or other impervious material placed in the walls just above ground level to prevent the damp from the ground rising through the foundations into the walls above. Such things can be inserted yard by yard at a time, but it is an expensive proceeding. If damp courses do not exist and are too costly to put in, it is all the more necessary to see that the subsoil is a dry one, such as gravel, sand or rock. A flagged basement assists in keeping a house dry if it is dry in itself. If, however, it acts as a sump or drain-pit for the surrounding soil, it, of course, makes matters worse confounded, because it ensures damp even in dry weather. Some of the driest houses are the old timber-constructed ones; if such had been damp their timbers would have rotted away long ago. They, however, if not damp are rather apt to be cold in winter and warm in summer, in spite of the cavity in their walls. The inner and outer coats of lath and plaster or weather-boarding are not really sufficiently thick for comfort. Such houses, therefore, need more heating than those with substantial brick or stone walls.

Let us now consider the walls a little. In most old houses they are strong and substantial. They may, however, have been neglected. Rain-pipes may have been left unrepaired, and frost may have entered and disintegrated the mortar. This, however, is not a very serious matter. A little re-pointing will set it right if it has not gone far. What is more necessary is to look at the state of timbers built into the walls. In most old houses these are plentiful both as wall plates and ties. There are two chief dangers connected with them—worm and dry rot. Either will turn them to powder or to a frail semblance of themselves about to fall to powder. In both cases there is nothing to be done but to replace them. Dry rot, however, is not a usual complaint of old houses. It is much more often found in new. It comes not so much from damp as from bad ventilation. A wood floor laid on concrete which has had linoleum on top of it so that the wood is effectually smothered both above and below is the sort of place where it starts. Unfortunately, once it starts it spreads very quickly. Old houses by their age, therefore, generally show themselves proof against it. Worm in the timbers is the reverse. This works more slowly, and is to be found in the

hard woods of old houses as well as the softer ones of new. As in chairs, a little dust like sawdust is the proof of its presence. Palliatives may be tried, but for the sake of one's furniture, if for nothing else, it is better to take the timbers out.

The roof, however, is generally a more important matter, as regards maintenance, than the walls. Roughly speaking, the order of covering materials in cost of upkeep would be thatch, most expensive of all, and only suitable to quite small houses, then stone-slates, tiles and, last of all, slates. But more important than the material covering is the construction. Look to see whether there are internal valleys and flats where snow and leaves can collect and check the flow of water till it penetrates. The less of such gutters and flats the better. When they exist they should be of lead, as indeed, they usually are in any decent house. Repairs, however, in these hard times may have been done in zinc, and zinc has a very short life in our climate. If the roof is of tiles, it should have been boarded over the rafters and under the tiles. Generally speaking, the steeper the roof, except in a very exposed situation, where the wind can blow the covering off, the sounder it is likely to be, for, of course, the water runs off more quickly. The slope, however is determined by the style of the house, and the materials by the slope. Slate, for instance, is quite safely laid at a much less steep slope than tiles, thatch or split stones. Being a truer material it lies closer. An over-all roof in two or four plain slopes with no breaks in it is, whatever the material, the safest form. The water is then shot everywhere into gutters clear of the walls or into a simple lead trough behind a parapet. There are then no internal and half-hidden gutters to leak and pour water down the centre of the house. Indeed, it may be laid down as a general axiom that simplicity of mass and form, given equally good construction, means cheapness of upkeep. A simple cube or rectangular mass with a plain roof hipped all round with no gables or dormers would be the most compact and cheapest of shapes, not only to build, but to maintain. Such things, however, are obvious. Let us now consider the internal arrangements.

The first question in these semi-servantless days is whether the old house of one's choice can be adapted to the restricted post-war service which is all that most of us can afford. It behoves one, therefore, to see whether the rooms can be so rearranged, without expensive alterations, that the kitchen is not only reduced to a reasonable size, but is sufficiently near the dining-room. Generally the spacious old kitchen, with its flagged floor, its stretch of cooking apparatus down one whole side, with open range, hot plates, ovens and boilers, had better be abandoned. Sometimes it will make a billiard-room later and sometimes even a garage. Perhaps the old pantry or scullery can be turned into a modern kitchen. The point is that in any

case you will need new cooking apparatus on a reduced scale, but with greater efficiency. The expense is when you have to build a new room for it. See, therefore, whether you can avoid doing this by a readjustment of function in the various rooms. The ideal arrangement, both in a new and old house, is a small pantry between the dining-room and the kitchen with the service through it. The pantry so placed acts as a buffer to noise and smell from the kitchen, and yet is handy for setting things down. However do not spoil a vista or some real architectural feature by giving up a good sitting-room to a modern kitchen. If you love the beauties of your house you can often pay too dearly for conveniences. The same remark applies to baths. You will probably have to find extra space for them, but it is obviously a sacrifice to give up to one a good bedroom on the main front. With modern plumbing, in which the bath water is at once taken outside the house and discharged in the open into a rainwater-head, there is, in my opinion, no objection to a small bath in each bedroom provided a suitable recess or space can be found for it. The small American deep tub bath in which one can sit with the water over one's shoulders, but not lie full length, takes little space and gets over many difficulties of placing. The safe general rule on all these questions of adapting an old house to the conditions of to-day is to see whether for kitchen, motor car or baths one can install the new requirements without rebuilding or serious additions. On every ground that is the safe proceeding, whether to preserve character, to avoid the clash of old work with new, or merely to save outlay.

XVI.

WREN AS A BAROQUE ARCHITECT.

WHAT is the quality in Wren's work which gives it the very human appeal it undoubtedly possesses? How is it different in this respect to the work of Inigo Jones? Why do we all in our hearts love any of the façades of St. Paul's better than that of the Banqueting Hall, or, if that is to compare things that are incommensurable, what is the quality in Trinity Library, Cambridge, which endears it to us, while, as we pass down Whitehall, we view the Inigo Jones building with respect and admiration, but hardly with any sense of deep affection? We may even breathe a sigh of thankfulness that we did not have the mile or two more of it Jones intended.

It is an interesting problem, and one I think worth a little consideration. Twenty years ago, when Belcher and Macartney's "Later Renaissance" was issued, Wren's work appeared the final word in architecture. No one challenged it except the Gothicists. Gradually, however, the younger architects discovered architecture had not stood still since the 17th century. Each of us pushed our enthusiasm a little further, some pinned their faith to Chambers, some to Robert Adam. Some even went as far as measuring Cockerell and Elmes and the later Greek work. Finally there appeared Professor Richardson's "Monumental classical Architecture in Great Britain and Ireland," and at last we thought we saw the whole thing in perspective. All the time, however, there were very vital folk like Sir Edwin Lutyens and E. A. Rickards who stuck to Wren. The former is even reported to have said that the English Renaissance ought to have been spelt the English Wren-naissance. So to-day, especially with Wren bicentenary just past, we are all beginning to cast our eyes back to the great 17th century master and find that, incorrect as a great deal of his work was according to all the rules of the game—coarse as a great deal of his detail undoubtedly is, with faults of taste and inconsistencies of scale—there was something very rotund, full-blooded, almost Falstaffian, in the mass of his work, which makes us give him an affection we give no other. In comparison the work of the later men, especially of the Neo-Grec ones, seems hard, even spikey. It is all very well for the historians to tell us of Wren's mathematical genius and the consequent sublimity of his conceptions. That, I beg leave to say as regards his architecture, with the possible exception of Greenwich, is what is vulgarly called 'eye-wash.' The dome of St. Paul's is a paltry affair compared to the dome of St. Peter's and only insular prejudice would say otherwise. Its tricks of construction are no doubt evidence of mechanical ability, but

such are not architecture. Internally with its muddle of unequal supporting arches or externally with its tight unmodelled surface it is very inferior to its great prototype. Yet the lovable quality of the work remains especially in that nearer the eye. Think of the Dean's doorway under the great recessed arch of the window on the side of the North tower, or that other lovable doorway, with its oval window and fat cherubs also under a recessed arch in the tower of St. Mary-le-Bow. What comfortable happy invention! What richly curved surfaces; what cheery display, designed, one may be sure, with sheer enjoyment.

In a very obvious sense all Wren's architecture is civil architecture, his cathedral and churches not less than the rest. He built in an age of humanism, when paganism was no longer feared. As Miss Milman has wisely said in her life of Wren, a church with him "would differ from a court of kings only in being more full of splendour." This was the renaissance spirit, but it was the spirit more particularly of the baroque period when, freed from the rules, though remaining masters of them, men built for sheer swagger. It was in this spirit the Jesuit Churches of the counter-Reformation were built. Knowing human nature, those wise men chose a style for their sacred edifices full of dramatic human appeal. So did Wren, as far as he knew and could. I venture to suggest that it was because he had in himself a large share of this baroque spirit, this happy posturing, and not because he was a scholar and a mathematician—rather because he broke the rules instead of following them, because in essence he was not a Palladian like the majority of English architects—that he is loved to-day not only by architects, but by the great mass of the people as no other architect has ever been. I realise that in attaching the term "baroque" to Wren I am running the risk of libelling him in the minds of many. That is because of the unfortunate ill-odour which nowadays hangs to the word. The baroque is synonymous with decadence we are generally told. Indeed the ordinary text-books, like Anderson's "Italian Renaissance," either treat the great parent baroque work in Italy with a few contemptuous remarks, or leave it alone entirely. Yet one can hardly label as decadent a style which covered Italy with the most vigorous buildings it possesses, which gave the colonnade and baldacchino to St. Peter's, which planted the superb mass of Santa Maria della Salute at the end of the great sweep of the Grand Canal— to mention but two examples.

What is the real function and intent of baroque architecture? Geoffrey Scott defines it very well—"to give the picturesque its grandest scope and yet to subdue it to architectural law." "The baroque is not afraid to startle and arrest." "It enlarged the classic formula by developing within it the principle of movement. But the movement is logical; it is logical as an æsthetic construction, even when it most neglects the logic of material

construction. It insisted on coherent purpose, and its greatest extravagances of design were neither unconsidered nor inconsistent. It intellectualised the picturesque." Baroque buildings, he goes on to say in effect, may do all the above, "yet their last and permanent impression is of a broad serenity; for they have that baroque assurance which even baroque convulsion cannot rob of its repose. They are fit for permanence: for they have that massive finality of thought, which, when we live beside them, we do not question, but accept."

Now I do not want to suggest that the full baroque spirit is to be found in Wren's work. It is obviously much too staid and too English for that. But I do think that there is more of it there than we have been accustomed to realise and that it is because it is there, giving vitality and humanity to his architecture, we return with more affection to his work than we do to that of either Inigo Jones, his more academic predecessor, or to any of his Palladian successors. To my mind it was very fortunate that instead of going to Vicenza, as Jones did, Wren escaped not only the plague by going to Paris, but went there at the very time the great Bernini visited that city. One can imagine that these two men, both so energetic, vigorous and long-lived, both to accomplish a prodigious amount of work in their lives, would be very much of the same kidney. The influence of the elder, at the height of his fame and treated as a prince by the French, on the young Englishman, who till then had built but one or two small structures, who came seeking information in every direction, was very likely immense. If one looks for similarities of thought in design in Wren's later work with that of Bernini, they are not difficult to find. The great doorways of the Chigi Palace are echoed in those of the river front of Trinity Library, while the altar-piece of the Chapel of Chelsea Hospital might have been designed by Bernini himself. It has the same sumptuousness, the same great scale, and the same use of coupled columns. In the All Souls' collection of Wren drawings there is, too, a design for a monument, with twisted columns covered with garlands, a sun-burst, gesticulating angels and fat descending cupids—all in the best baroque manner. This latter however is an extreme example, only quoted to show Wren's knowledge of baroque detail. It is when Wren is most like Bernini in his decoration and less like the contemporary French artists, with their insistence on free foliage and asymmetrical ornament, that he is most satisfactory. The altar-piece at Chelsea is infinitely superior to the more often quoted one at Trinity College, Oxford, where indeed the baroque may almost be said to sink into the rococo.

"To give the picturesque its grandest scope and yet subdue it to architectural law"—what better description could we have of Wren's towers? "The baroque is not afraid to startle and arrest." Think of the

sturdy chapel of Emmanuel College, Cambridge, swaggering with its big Corinthian order, its boldly broken pediment and its upstanding cupola, among the timidities of Tudor Gothic. "It enlarged the classic formula by developing within it the principle of movement." Think of the barrel vaults and saucer domes in the chapels and aisles of St. Paul's or the gay little Temple Bar neatly striding across the Strand. "Baroque buildings are fit for permanence. They have a massive finality of thought." Trinity Library has just this quality in supreme degree. Its last and permanent impression is indeed of a broad serenity, which the back elevation to the river possesses in an even greater extent than the courtyard front. But other buildings can be serene beside baroque ones. The point is that this building of Wren's has the rich modelling, the warm vital spirit which in classical architecture is the peculiar quality of the baroque and the baroque alone. All we know of the man himself bears out this view of his architecture. In a pedantic age he was no pedant. He had the enquiring mind so characteristic of the 17th century, which sought new knowledge in every direction, leaving it to be tabulated and scheduled by the colder and more precise 18th century. We have preserved in the Parentalia several of his exuberant letters, including one charming love-letter to the lady who was his first wife. We know that like Michael Angelo he worked till he was nearly ninety, compressing an immense amount of labour into his later years, and that like him, too, his fiery spirit could not brook opposition. The list of his executed works compares to-day in extent with that of a great American architect, but to superintend that work he had to travel many dreary days on horse back. He must have been a man of magnificent physique and we know that he had a gay happy spirit. All who met him delighted in his wit. His friends were legion. He knew everyone worth knowing and had achieved fame in other walks in life before he began his proper work. He was an honorary doctor both of Oxford and Cambridge before he became an architect. It is difficult to imagine such a man blindly following Vitruvius Palladio, Serlio, or any other theorist. He might, and no doubt did, confound the ignorant by quoting them; but in his own practice I feel confident he relied on his own innate genius for expressive form, and that genius led him towards those self-confident happy, almost swaggering, shapes we now in their fulness call baroque. It is in his combination of such forms with the more sober methods of English buildings that the great lovableness of his work lies.

XVII.

THE ANTI-SOCIAL CONTRACT.

ONE of the troubles in obtaining good buildings to-day, as everyone who has tried in the capacity either as owner, architect or builder must realise, lies firstly in the system of asking for competing tenders from builders, and secondly in tying down the lowest tenderer to carry out the work under a strict and binding legal contract. We look on the builder as a contractor and call him such. His chief function in modern eyes is to undertake to do a carefully specified piece of building for a fixed sum. His profit is not specified and he is free to make as much as he likes out of his operations as long as he carries out the specified work in the specified way. The real difficulty is that by no manner of means yet devised can the work be specified beforehand with absolute accuracy, nor has any means yet been discovered by which, in all the multifarious processes of building, it can be ascertained whether what has been specified has been actually carried out. We may make drawings as complete and thorough as is humanly possible; we may write long specifications and have the number of bricks, and the amount of all other material and labour to be used, assessed beforehand by a quantity surveyor, yet quality of material and workmanship enters so largely into every stage that no one can definitely say at the end that the contract has been carried out to the letter. Further, we may appoint clerks-of-work and other watch-dogs to follow the contractor at every step on the building itself, or rather to attempt it, and yet we may be fooled by work made off the site and brought to it, or by work done on the job and covered up before the architect or any of his agents, including the clerk-of-works, can see it.

The contract system of building means that directly the contract is signed, the architect, representing the interests of his client, and the contractor are there watching one another like rival detectives in a divorce case. The contractor to obtain the contract has probably put in too low a price. Everywhere in material and labour he is anxious to save except where he can find, as in practice he always can, excuse in the specifications and drawings for extras, when he is equally anxious to spend unnecessary money. I do not want to suggest that the majority of builders are not honest. Without any dishonesty in carrying out a contract, which he knows will be strictly enforced against him, the builder uses his wits to make the best living he can. If he has done a good deal of work for the same architect he may take a long view and say "I had better not do such and

such a thing, because if discovered this particular architect will not ask me to tender for his work again." I admit this often happens and to a certain extent the rigours of the contract system are thereby tempered. But who, outside a lunatic asylum, under such a system and under modern conditions, would expect good craftsmanship to flourish and good sound building to arise? That it does flourish now and then, and that good sound buildings are put up occasionally is a miracle, which I, as an architect, can only put down to some strange innate goodness in the breasts of many builders. I am afraid this goodness is chiefly to be found in those who are styled old-fashioned, in firms that have a tradition and in craftsmen who love their work, whatever they may in a monetary sense make from it.

But why should this state of affairs exist? Why should the builder be on one side and the architect on the other? Why should they not be colleagues from first to last, each helping the other with his experience? The answer is that this happy state of affairs can only take place to the benefit of everyone concerned, and particularly of the building owner, if the ordinary contract based on cut-throat tendering is abolished. By far the most satisfactory work it has been my lot to carry out, as well as the most enjoyable, has been that done under a different system—a system of actual cost plus a fixed profit. In this, to begin with, a careful estimate is made by independent quantity surveyors of the cost of the proposed work, and both the builder and the architect's remuneration is fixed from the outset. If the building costs more than the estimate, neither profits by the excess. Of course the architect's commission of six per cent. is so small that it cannot be considered any temptation to him to increase the cost of the building for the sake of it. Still it is more satisfactory, as an example to everyone, and more pleasant for the owner, to know exactly what he is going to pay each person.

What is the result? Everyone starts on the building operations as friends and helpers. In place of antagonistic individual effort you have team work. The larger experience of materials, which the average builder who works for many architects possesses, is placed at the architect's and consequently at the client's disposal. If he suggests red deal instead of yellow for a certain piece of work the architect has no reason to suppose he has some hidden motive behind his suggestion. Under the present system the architect is wont to jump to the conclusion that the yellow must be the better, because the builder has suggested the red, and, if the yellow is in the contract, he will insist on it till all is blue, and if the contractor makes a loss, he will take care to make it good elsewhere. And after all, the red might have been better for the particular position. We all know, however, even as free-traders, that the desire to buy in the cheapest market has many qualifications. Among them is human nature, and there is a great deal of

human nature in building, and especially in good building. If when we set out to build we want real value for our money, as well as buildings which will be of real value to the country when we have done with them, the sooner we abolish the ordinary form of building contract the better. That is why I have called it the Anti-Social Contract.

XVIII.

AN INDICTMENT OF COAL SMOKE.

A LARGE northern city without smoke, or indeed any English town where human beings for business reasons have to live in close proximity, is a little difficult to conceive. If it came about suddenly we who live in such places might feel not a little naked and awkward, so accustomed are we to our own dirt. We are apt, indeed, to think that dirt and dignity go hand in hand. A poet friend of mine, who had gone to live in Leeds, told me that one day on visiting his bank in that city, instead of finding it the massive gloomy black pile he expected, it stood out before him as a trifling white building in glazed terra-cotta lately washed. All its dignity and half its financial credit in his eyes had gone. Such it is to be suddenly clean in black surroundings; where before the crudeness of the architecture had been decently covered in soot it now stood forth unashamed in all its absurdity. It was a test the Leeds bank building could not stand, and it is one very few of our more modern classical buildings could. To them the smoke deposit is a grateful one, softening their crudities.

Manchester, however, has lately been cleaning, with the aid of a sandblast, some of her older classical buildings dating from a pre-smoke era, and these have stood the test nobly. The Theatre Royal is a good example. From this one might argue, and I think with some fairness, that as the pall over our towns has become heavier so our architecture has deteriorated. I think it is really a case of cause and effect, though admittedly other things aided in the decline. What is the use of Greek delicacy and refinement in mouldings and ornament when an oily black deposit will very quickly obliterate them and, as has been proved time after time, in a few short decades crumble them away? The good architect is likely to give up hope, and devote himself to clean buildings in the country, where not only mouldings but even texture counts. So we have in our smoky English towns our heavy over-ornamented buildings trying by over-emphasis in every direction to force their way through the grime, and in a clean smokeless town, like New York, light gay buildings with clean line and surface and delicate ornament leaping up to the light and trusting to their general shape and mass for their main effect. The sunny city brings about bright clean-shaven buildings, the smoky one be-whiskered coalheavers grinning at us in their oily facetiousness.

What Manchester or Leeds would be like in a few years' time for an architect to work in if the tons of tarry acids and soot from their domestic

chimneys—the chief offenders—went down the sewers, as such refuse should as long as it remains refuse, instead of falling on our heads and our buildings, is difficult to imagine. They would, one may be sure, be towns of peculiar beauty, a beauty, too, very different to that of the sunny towns of the Mediterranean. Instead of the bright colours belonging to a lower latitude we should have the far more beautiful half-tones and pearly greys belonging to our northern climate. Our buildings to correspond would have to be more delicately modelled, with less strongly marked shadows. Deep porticoes would rarely be used save to mark points of special importance. The architect, instead of being a man accustomed to think in black lines, would become sensitive, not only to every shade of colour, but to every modulation of surface and texture. No longer could we tolerate the hard, bright, cheery reds of our machine-made pressed bricks. The black joints, too, in which we set our brickwork, grinding cinders into our mortar where the south uses sand, would seem to be what they are, so many dirty lines drawn across the fair faces of our buildings, and thereby adding most unnecessarily to the gloom. A vulgar moulding too, an over-emphasized piece of ornament, would become so conspicuous in proper daylight, when all the surroundings would be clean, that the author of it would begin to be cut by his fellow-architects, and even his lay friends as a man of bad and flamboyant taste. For it must be remembered we have already reached the stage where a sin against taste, when realised, is far worse than one against morals. Indeed, the reactions of clean air and the beautifully tempered sunlight which really belongs to Lancashire would be infinite. With the coating of soot removed from our lungs as well as the black from our buildings we should probably all talk with the sprightliness of the Athenians of old. An architectural public opinion would be one of the first things to form, and woe betide the architect and client who spoilt with his coarse work our modern Athens. An effect which old Athens lacked we could have in abundance. The foliage of beautiful feathery yet rounded trees suited to a town, which grow in our climate but not in hers, might make the foil to the buildings of our main streets which the London plane trees do to the painted buildings of the London squares. Our parks, too, would become clean. They might then cease to be the dreary recreation grounds, with asphalt paths and a weedy sprinkling of grass, we now assume, unrightly I think, to be all that is possible in the heart of a city.

All this I realise may be thought fanciful, though it is fancy based on fact. Here, then, are solid facts no one can dispute. Sir Frank Baines, chief architect to the Office of Works, than whom no one has more experience of the upkeep of buildings, stated in his evidence before the Committee on Smoke Abatement that the cost of the upkeep of a building would be reduced by at least half if a smoke-free atmosphere obtained. The material damage to Manchester by its own smoke has been calculated at £1,000,000

a year. But more important even than these figures is the disrepute and disregard into which its soot has brought such towns. There is the story, probably apocryphal and certainly unwarranted, though useful enough in pointing a moral, of the Cabinet Minister who had a speaking engagement, and not feeling very well went to see a leading consultant, and asked whether he was fit to keep his engagement, which happened to be in Manchester. "Manchester?" said the consultant, "certainly not. Nobody is well enough to go to Manchester."

Owing to their smoke and dirt, no one now lives in our northern manufacturing towns who can afford to live outside them. They have become mere workshops, and, with the Englishman's disregard for the surroundings in which he works, they are yearly losing what little amenities are left. When the eighteenth-century merchant lived in his square dignified Georgian mansion, with its touch of Dutch brightness and cleanliness, and walked to his equally dignified counting-house, the appearance of the city he walked through was a thing of some consideration to him. Now, when he motors into it for a few hours in the middle of the week and is landed at his office door with hardly time to see the buildings he passes, having his attention directed chiefly to the traffic and the policemen, not only his interest in his town but his knowledge of it is infinitely less. The place he makes money in is not worthy of his thoughts except for that purpose. With the more influential classes feeling like this, it is no wonder that the others feel even less interest and responsibility as they hurry away in their tram-cars to their distant suburbs. So the rot, started by the smoke, spreads until the town becomes the black, formless, slightly smelling abomination we begin to believe it must be. Yet all the time there are Paris, Vienna, New York, Düsseldorf, and Cologne, indeed almost any town but one of our own, to show that in reality the town is and may be something very different—the highest and finest expression of communal life, the place where service and work and the consequent enjoyment of them can alone be carried to the highest pitch.

XIX.
THE BUSH BUILDINGS OF NEW YORK AND LONDON.

NOTHING could illustrate better the versatility of the leading American architects or the eclectic character of modern American architecture than the Bush Buildings in New York and London. If we wanted to go further we could illustrate this thesis from two other almost equally important works by the same architects, Messrs. Hemle and Corbett. There is their great and splendid Italian basilican church at Brooklyn and their Washington Memorial Masonic Temple, a vast and powerful monumental building in what we should call in England Neo-Grec architecture. These four great structures, either of which is sufficiently striking and competent in every implication of the word, to make the fame of an ordinary English architect, are therefore at the four poles of architectural expression, if we exclude modern attempts at futuristic design. In the England of the end of last century we should have explained this phenomenon easily enough, or at any rate the younger men would, on the simple hypothesis of ghostly designers. But that will not do in this case or in the similar cases of other American firms like Messrs. York and Sawyer, or McKim, Mead and White, which show the same universality in their work. In Mr. Corbett's case, for his partnership is frankly and openly that of a designer and a business man, from experience of his office I happen to know that all this diverse yet splendid achievement is the work of one man, Mr. Corbett himself. Yet this does not measure his output of creative energy. Apart from his lesser architectural work, like apartment houses and the four great buildings mentioned, all erected or in the course of erection within the span of a few years—for he is still a young man as measured by the heads of the architectural profession in this country—Mr. Corbett finds time to carry on the most successful design atelier in Columbia University. Two nights a week he criticises the *projets* of some 25-30 young architects, making the constructive suggestions every teacher worth his salt has to make. I met him late one night when he told me he had that evening sketched fifteen different solutions to the same problem on as many student drawing boards. How does this extreme competence, combined with almost absolute freedom from a predilection for any particular form of expression, arise? Obviously it is an intellectual phenomenon divorced from faith in any particular tradition. The only answer I can find to it, and I think it is a satisfactory answer, is that it lies in a combination of the extremely logical Beaux Arts system of education with the alertness of the quick-moving American mind, always open to fresh ideas. Mr. Corbett was trained in

Paris, and after that had the usual period of assistantship in great offices like Mr. Cass Gilbert's and Messrs. McKim, Mead and White's. In his own case he has never believed in nor possessed a great office staff as measured by American standards. He once told me that he felt fifteen draughtsmen were as many as any man could feed with ideas. After that they began to feed you. It seems a rational limit though one knows it is one often exceeded even in England.

With these preliminary remarks let us consider his two great Bush Buildings both designed to answer the same programme—a permanent exhibition of travellers' samples—and both converted or partially converted to office purposes, as foreseen would be the case, while the idea of such an exhibition gradually obtained acceptance. The programme from the outset therefore obviously divides itself into two aspects, that of providing large unencumbered exhibition floor space capable of temporary sub-division into offices, and that of giving the total building in each case the commanding appearance, which will make it a prominent feature in a great city. We know how well Mr. Corbett, even in the small section of his total scheme which has been built already, has solved this two-sided problem in London. His New York building, perhaps, is less well know. Let us therefore start with that.

In New York Mr. Bush had chosen a site for his venture in 42nd Street, a street which seems to me roughly to correspond to the Strand. That is to say it is a street half way between the City and the West End, near to the great commercial hotels, most of which are indeed in it. It is in a growing neighbourhood too, into which important industrial concerns are continually moving from the crowded down-town area. Hence under American conditions the surrounding buildings are continually getting larger and higher. The site Mr. Bush was able to buy was a very narrow one, some fifty feet wide, in the centre of a city block. It would only get light, therefore, back and front. Further any buildings rising above its fellows must be prepared in such circumstances for the blank return walls, which are one of the ugliest features of American building conditions. If the site was a narrow restricted one it was however 200 feet deep, and compares therefore, in total area to about two-thirds of that occupied by the central block of the London building. To develop fully such a site it is obvious that only a portion of the building could rise to any height, because only a portion of the total depth could be lit from either end. Mr. Corbett chose to take up the front portion using some 90 feet of depth for the purpose. We, in England, with our duller climate, would consider 90 feet a great depth to be lit from either end, or from a small enclave in one side, which might some day be built up. To get his exhibition floor area then, and to give the striking character his building demanded, this area of 90 by 50 feet

was made into a tower, and a very lofty one at that. It is 450 feet high—higher, that is to say, than the cross on St. Paul's. To build a great tower on so narrow a base was in itself no small engineering undertaking, especially as the large exhibition rooms on each floor made cross bracing against wind pressure a difficulty. To make an oblong tower with the two longer walls not only blank, but devoid of all projections, however slight, for adjacent owners in America do not grant accommodation of that kind, a beautiful and graceful object was an architectural undertaking which it required no small ability to accomplish. The choice of Gothic as the form of expression to be used was probably dictated by the simple fact that Gothic lines would emphasize the height of the tower—its main characteristic—and any other style would diminish it. One can at any rate imagine the architect trained in logical French methods arguing in that way. The difficulty of the blank returns was overcome very ingeniously by imitation details of long mullion-like lines in three coloured bricks, black ones being used for the darkest shadows, which are made to correspond to the natural average angle of the sun, while white bricks are used for the high lights. The very thought of this would make Ruskin turn in his grave. Yet the result is undeniably effective, and one cannot see how so good a result on an absolutely plain face could be otherwise obtained. But the tower, of course, does not really rely to any great extent on this successful architectural camouflage. It relies on its undoubted grace, which is largely due to the very beautiful double lantern or 8 or 9 stories which surmounts it. This lantern by being set in from the main wall faces is freed from restrictions. The upper portion of it sets in again and the architects have here their own office with all New York from river to river and mountain range to mountain range at their feet. At night the lantern top is illuminated by flood lighting, and floats high in the sky, a golden casket of extraordinary and romantic beauty.

The building is Gothic throughout, with elaborate bank and club rooms on the lower floors, but one must frankly admit that while it is far better Gothic than that of the Woolworth Building, it is like the interior of our own Houses of Parliament, Gothic without the touch of the Gothic craftsman, and the variety and interest of Gothic designers. My own feeling is that no human being can design Gothic detail on paper in the quantity which these great buildings require and give it the real interest and spontaneity of the old work. Sir Giles Scott has got nearer it than anyone in his Liverpool Cathedral by departing very largely from precedent. Mr. Corbett has departed from precedent too, but his thirty odd floors, like the endless corridors of the House of Commons, call for a greater output of ability in Gothic designing and craftsmanship than the whole world possesses at the present time, and it must be remembered as stated above, Mr. Corbett is his own designer.

Let us turn now to his London building. It is so well known and so much has been written about it that it is not necessary to describe it in any detail. One may notice, however, how the dual aspect of the problem has here too been solved. The great doorway with its giant columns and semi-dome facing down Kingsway, with the crowning tower above, emphasize the semi-public character of the proposed commercial exhibition or museum. The great mass of plain stone face showing everywhere in cliff-like walls, among its complicated neighbours, all piers columns and architectural trappings of every sort, marks the London Bush building as being as distinctive a unit in London as is the graceful tower piercing the sky in New York. If it ever fulfils its owners' conception and becomes a great depository of current articles of commerce, it will stand out to the world as such a depository. The man in the street will easily recognise it as such. There is rightly more than a touch of the warehouse character in it. The architect seems to me, therefore, to have solved that side of the problem better even in London than he has in New York. The New York building is a more obvious advertisement. Its tower is simply a beckoning finger. No one would expect a graceful Gothic tower to be a storehouse of samples. The other half of the problem is equally well solved by the London building. The great floors, admirably and evenly lit by the evenly spaced windows, make excellent exhibition galleries. In the meantime they make almost equally good office floors. The regular spacing of the windows, which allows them to be smaller than is usual in London and thereby gives the greater wall spaces we all desire, makes each floor readily divisible to suit tenants. The practical conditions of the problem seem therefore to have been solved as admirably as the more spiritual ones.

The measure of success which this central block only of the whole London conception has achieved is extraordinary, when one remembers that a great deal of it will not be seen when the two big wing blocks are built, and was so designed. There is a baldness about the flanks as at present exposed, which will be very suited to the two garden courts, when they are completed, but which is not so happy now. The fact, too, that the main central block is not axial with Kingsway will not then be so apparent. It is not axial because its axis is a necessary compromise between the centre of Kingsway and the centre of the curve on the Strand front. This deflection of the axis of the central block was, in my opinion, very much to be preferred to a break in the back of the block itself—the only alternative.

The clean lean character of the exterior, relying for its final effect on the mass of the building rather than on any excitement of detail, appears to me to fit with our current post-war ideas in a way which is little short of marvellous, when one remembers that the building was designed before the war. One may ask what has the war got to do with architectural styles? I

think that the answer is that the war with its consequent economies is enforcing a healthy movement, which had already started, towards buildings, which answered their programmes more directly and without unnecessary fallals. The Adelphi Hotel and the Cunard Buildings at Liverpool, both pre-war, are early examples of the same trend. The main impulse, however, came from America, where commercial buildings had become so large that columnar orders could no longer be fitted to them, while the windows had become so small in comparison to the structures as to be mere texture to the wall surface. Buildings like the Port of London Building are already *demodé*. They mark the end of an era. The young men now coming from the Schools of Architecture are coming forth with very different ideas. To them the London Bush Building is a welcome advance in logical expression, which they themselves hope to carry still further. Its discreet detail is based indeed on tradition, but is no thoughtless copy of old dead things. It combines reserve with boldness, logical character with great taste and knowledge. No better background for large sculptured figures standing clear could be imagined than the great rich semi-dome to Kingsway. This portico marks the public entrance to the whole building as appropriately as does the smaller one in the Strand the entrance to the bank or insurance office to occupy the Strand portion of the ground floor. Fitness in expression seems to me as much inherent in the detail as in the general conception. It is because of this logical fitness and efficiency throughout that the Bush Building holds out hope for the future. It has not been born dead as are so large a proportion of our modern town-structures. Viewed from this standpoint, it seems to me far more alive and valuable than the corresponding New York tower. The idealism and hopefulness, which all who have met him know to be so leading and interesting a characteristic of Mr. Bush himself, has, thanks to his architect, found expression in his London building. Here is honesty, simplicity, faith in and hope for the future. It is no small gift he and Mr. Corbett between them have made to London, especially at the present time. May they soon complete it as planned!

XX.

BATH OR BOURNEMOUTH?

BATH is our one architectural city. Sufficient of it, that is to say, has been built on an harmonious plan and with harmonious architecture to give it a unity no other town in Great Britain or Ireland possesses. Dublin, before the recent fighting, was nearest to it in this respect. When the fighting is really finished and rebuilding starts in earnest, it will probably fall a little further behind, for to-day there is nowhere any canon of taste sufficiently strong to force any sort of uniformity on new buildings. That is where we differ most strongly from the 18th century. Bath was not built by one architect, though one was responsible for most of the lay-out as must always be the case where there is any plan at all. The actual buildings of Bath were built by a group of architects no more closely connected, except in general ideas and taste, than are modern architects. Yet how different the result! Think of Bath with its stately procession of noble streets, squares, circuses, crescents and other architectural forms and the modern town which most nearly answers to the same requirements—Bournemouth. The contrast could not be greater and in itself is a good measure of the difference in ideals which separates the builders of the eighteenth and early nineteenth centuries from those of the latter half of the nineteenth and the twentieth centuries. In the place of a dignified neighbourliness and sense of solidarity which led folk to live in terraces of houses, which externally did not differ from one another, we have, as exhibited in Bournemouth, or in any other modern recreational town for the matter of that, the evidence of a desire to live as far removed as possible from one's neighbours in a house which differs in shape as much as possible from theirs. In Bath in the eighteenth century one did not show one's superiority by any outward display. The greatest in the land were ready to live cheek by jowl with the least famous. A circus or crescent might house for the time being, at any rate, great ministers of state, dignitaries of the Church, members of the aristocracy and retired tradesmen in houses whose exteriors were identical. We often pride ourselves a little superficially on the superior democratic tendencies of the age in which we live, yet if architecture is used as a test we see at once how much more really democratic a city layed out on the lines of Bath is to one on the lines, or rather one like Bournemouth, for the latter has no lines at all in an architectural sense. I do not want to say that the garden city idea of which Bournemouth is an early, if unconscious example, has not beauties of its own. I only desire to point out what a very

different ideal of beauty the two towns and the two centuries they stand for exhibit.

Another difference, which is really involved and implied in the two different conceptions of what a town for rest and recuperation should be, is to be noted in the way each town approaches the country. The modern town has always its indefinite region surrounding it, which is neither town nor country, but an ugly and generally an untidy overlapping of each. The whole of a town of the type of Bournemouth is suburban. That is involved in its idea, but there are parts of it on its outskirts where its suburban qualities lapse into meanness. In eighteenth century Bath there was nothing of the sort. The town and country did not mix and consequently neither spoilt the other. There was perfect town and perfect country co-existing side by side. The proof of this is still to be seen to-day in Great Pulternay Street,—the most dignified and perfect town street I know. As you walk down it you feel that you are, at any rate for the time being, a citizen of no mean city. Its urban flavour is of the most refined and exquisite kind. It has its proper climax in Sydney House, and there are no loose ends to distract the view in any direction. It might be a street in Paris, but devoid of Parisian noise and push and with statelier architecture. Yet a hundred yards to the right, through New Sydney Place, you have to-day open fields and completely unspoilt country. On the opposite side is the modern suburb of Bathwick, and you can note the difference. When Pulternay Street was built, however, it ran straight out into the open country, and its four-storied town houses must have backed on to the fields. Portland Place and the Bloomsbury Squares must have been very much the same when they were first laid out. The creeping of the modern town by means of inferior houses growing up higgledy-piggledy or in long dull streets leading nowhere, with all the squalor and discomfort to everyone such a condition implies, is, I am afraid, a modern conception, or rather the absence of any conception at all. When in the eighteenth century, owing to its sudden rise in fashion, Bath burst its medieval walls, as did so many English towns, it did it deliberately according to an architectural plan. The result was, instead of the area of muddle through which one drives as quickly as possible in approaching a modern town, no muddle at all, but fine trees and stately country adjacent to fine houses and stately streets, each enhancing the other. Let us consider a little more closely this method of town building and town planning as exemplified in Bath.

The man who transformed Bath from a small medieval town surrounded by its walls and with its two main, though irregular, streets running roughly at right angles towards its four gates, after the pattern of a Roman camp on which, no doubt in this case, it was based, was a young Yorkshireman of twenty-one years of age, named John Wood. He was born in 1704 and

employed as a surveyor of roads in his native county. He appears to have been introduced to Bath by Ralph Allen, the post-boy who rose to be the great merchant prince of the town, owner and developer of the quarries of the famous Bath Stone on Coombe Down from which the town is built. In "An Essay towards a Description of Bath," which Wood published in 1742, he says "In 1724 a subscription was opened by a deal merchant of Bristol for carrying the navigation of the river into execution, so that when I found the work was likely to go on I began to turn my thoughts towards the improvements of the City of Bath by building, and for the purpose I procured a plan of the town, which was sent me into Yorkshire in the summer of the year 1725, where I, at my leisure hours, formed one design for the ground at the north-west corner of the city and another at the north-east side of the town and river." This latter was afterwards laid out by Thomas Baldwin, and includes Pulternay Street and part of the Bathwich estate. "After my return to London," Wood continues, "I imparted my first design to Mr. Gay, an eminent surgeon in Hatton Garden and proprietor of the land, and our first conference was upon the last day of December, 1725." Wood must obviously have been an extraordinary young man, not only to have conceived at the age of twenty-one in his leisure hours, a plan for developing a strange town on what were then very novel lines, but to have had the energy and capacity to convince the owners of the land and push the major part of it through to completion. "On the 31st of March following" he says, "I communicated my second design to the Earl of Essex, to whom the land on which it was proposed to be executed then belonged, and in each design I proposed to make a grand plan of assembly to be called the Royal Forum of Bath; another place no less magnificent for the exhibition of sports, to be called the Grand Circus; and a third place of equal state with either of the former, for the practice of medicinal exercises, to be called the Imperial Gymnasium of the City." In the November of the same year Wood fixed his preliminary articles with Mr. Gay, who then empowered him to engage anyone that he could bring into the scheme for the building of a street, 1025 feet long north and south by fifty feet wide east and west, for an approach to the grand part of the design. In this way Gay Street, leading to the Circus, was eventually formed and Wood launched on his numerous schemes for the betterment of Bath, which even included a canal from Bristol to that city. For the canal he obtained men from the Chelsea waterworks, and he says "till that time the real use of the spade was unknown in and about the city." "I likewise provided," he adds, "masons in Yorkshire, carpenters, joiners and plasterers in London and other places, and from time to time sent such as were necessary down to Bath to carry on the building that I had undertaken"; for this astonishing young man was not only an architect and town planner but his own contractor as well. "It was not till then," he goes on to say, "that the lever,

the pulley, and the windlass were introduced among the artificers in the upper part of Somersetshire, before which time the masons made use of no other method to hoist up their heavy stones than that of dragging them up with small ropes against the side of a ladder." There may be some exaggeration in this statement of Wood's—there probably is—but it is sufficient evidence of the primitive state of affairs in the city when Wood found it, and it makes more remarkable still the work which this young genius achieved. Not only, apparently, did he transform a medieval town into one of metropolitan and even Roman dignity, but he displaced medieval methods of handling materials and workmanship with modern ones.[1]

> 1. For the above facts and dates concerning Wood and his work, as well as for much else, I am indebted to Mr. Mowbray Green's excellent volume entitled "The Eighteenth Century Architecture of Bath" which will be found a mine of information as to architects and owners of most of the 18th century work in the city.

Let us now take a walk through the formal portion of Bath, which Wood laid out, and on which he and his son built their famous groups of houses. Starting at the top of Barton Street we enter Queen Square, the first of Wood's formal conceptions of a group of houses to be actually carried out. Queen Square was designed by Wood in 1728, and is roughly a hundred yards either way. It consists of four blocks of seven large houses on each side, combined into four architectural compositions. Wood claimed that he was the first architect in England to unite into one design a number of separate houses, but Inigo Jones had forestalled him in Covent Garden and other places. However, Wood was clearly the first to do it on this scale, and what is more important, first to combine one fine shape, like Queen Square, with other fine shapes like the Circus and Royal Crescent, and in this way to present the idea of an architecturally conceived town. The north side of the Square consists of a Corinthian composition with a central pediment over six columns and two square end projections with four columns and flat Corinthian pilasters in the links between. The order stands on a finely rusticated basement with moulded heads to the piers between the windows. The whole is strong Roman work but not lacking in refinement. The east and west sides of the square are conceived as the wings of a palace of which the north side is the main front. In the centre house of this north side under the pediment, Wood lived for a time, and died there in 1754, king of the domain he had created. The east side of the square was completed in accordance with Wood's design and has richly moulded and curiously carved doorways. In one of these houses, Dr. Oliver, of biscuit fame, lived. The west side, however, had to be altered to meet the difficulty of securing building owners and was not finished till

after Wood's death. The central block, with an Ionic Order in the Neo-Grec style, was added about 1830. All the houses of Wood's have fine interiors and well shaped and finished rooms and rich staircases with turned or twisted balusters and panelled dado. The staircase of No. 15 is perhaps the finest in Bath. Its alternate twisted and fluted balusters and handrail are all in Spanish mahogany. Above is some baroque plaster work very much like similar Italian work in the Georgian houses of Dublin.

Of the Square garden, Wood says the ground was enclosed with a low stone wall bearing a balustrade with a wide gate and gate piers on the centre of each side. In the middle was a basin forty feet in diameter supplied by a spring, and the four quarters of the garden were enclosed with espaliered elm and lime trees, though, as Wood adds, these must have somewhat obstructed the view of the houses opposite. The interesting thing to note is that all this careful finish was added to a scheme essentially speculative in character. The same remark applies to the houses themselves which Wood built here and in the Circus. Though the work was speculative there was nothing jerry about it. Wood used the best materials, especially in stone, the proof of which is to be seen in the state of the houses to-day. With the prospect of wealthy clients taking up his leases, he was content and indeed too much of an artist in his work not to build well, in addition to designing well. There is something therefore to be said, unprofessional as it sounds to-day, for this combination in one person of architect, builder and owner, which is to be seen too in the case of the brothers Adam, who so closely followed Wood and his son at Bath and elsewhere.

Passing up Gay Street, named after Wood's first Bath client, which has a number of the good houses in it, Bath accustoms us to, but nothing remarkable, unless it be the interior of No. 41 with its circular ended rooms, where John Wood, Jnr. lived, and "The Carved House," No. 8 on the opposite side, we come to the Circus, which is the finest of all the elder Wood's conceptions. The diameter of the Circus is about 100 yards and the height of the houses 42 feet. It is laid out with only three streets entering it and not four cross roads as at Oxford Circus or any of the other London ones. This at once gives it more solidity and a greater sense of enclosure as a circular court. It also enabled Wood to place opposite you as you pass up the gentle slope of Gay Street, a large unbroken segment of the curved façade, so providing an architectural finish to that street. In the Circus, Wood has departed from the strict Palladian manner as understood in England and, instead of great columns stretching over two stories and standing on a plain basement, he has provided a range of smaller coupled columns to each storey. Each of these rows of columns carries its full architrave, frieze and cornice and the top one a balustrade as well crowned with pine-apples. There is, therefore, a great profusion of strong horizontal

lines which emphasize the curve in whichever direction the eye is cast, while the rounded surfaces of the numberless columns give a sense of richness and fine modelling, impressive in the way that the exterior of the Colosseum or any great Roman Amphitheatre was. Indeed, walking round the Circus, you cannot help feeling that you are in the Court of Honour of some magnificent palace, yet by the absolute similarity of treatment to each house there is no individual ostentation or vulgarity. The Court is to-day splendidly enhanced by the magnificent group of trees which rise from the lawn in the centre. No wonder rulers of Empires like Lord Chatham (No. 7) and Lord Clive (at No. 14) and artists like Thomas Gainsborough (at No. 24) once took houses in it, while to-day it is almost entirely inhabited by members of the medical profession who have a knack of settling in the best houses in any provincial town. This Circus took fifteen years to erect, and was therefore completed by Wood's son, whose work was always in sympathy with that of his father. The exterior was, of course, determined once and for all with the first house built, but the interiors of the houses differ considerably and were probably designed to suit the requirements of the intending tenants.

From the Circus one passes by Brock Street, built by the younger Wood, to the Royal Crescent, another bold and magnificent conception on an even larger scale. It was commenced in 1767 and finished eight years later. Though the work of the son, it is in perfect keeping with the ideas of the father. It consists, too, of one continuous range of buildings with unbroken roof, forming in this case, a semi-ellipse, 538 feet long. Including the two terminal blocks, it contains a range of 114 great Ionic columns, here combining in the Palladian manner the first and second floors and standing on a plain base of the ground floor storey. The whole crescent, with its noble stretch of grass in front of it, looks south across the valley now containing the Victoria Gardens and has therefore, as it breasts the hill, one of the pleasantest outlooks in Bath. So successful was it in combining stately architecture with a fine prospect that it has been copied further up the hillside in other crescents, such as Lansdown and Camden Crescents. The individual houses in the Royal Crescent, being later than those in the Circus, depend more on plaster decoration for their interior finish, while the main doors are generally of veneered instead of solid mahogany. The ceilings of the chief rooms are particularly beautiful in a similar but rather stronger manner than that one is accustomed to connect with the name of Adam. It is again very like similar work in Dublin, and has like it in addition to the ordinary classical *motifs* an occasional touch of very effective naturalistic ornament, such as one finds in contemporary French work. The marble chimney pieces in the chief rooms are of the various eighteenth century types but with fine simplicity and restraint. Everything indeed was done to make these houses, while identical on the exterior, full of interest

and refinement within. In this way they satisfied the ideals of the eighteenth century gentleman for whom they were designed.

All these houses indeed of the two Wood's and the fine shapes into which they combined them seem to show that in times of good taste in the world it is almost as impossible to do wrong in architecture as in times of bad taste it is to do right. How otherwise, except by a general atmosphere of right feeling in such matters and the general acceptance of a canon such as the Palladian one, are we to explain the fact that John Wood, hardly more than a boy and an untravelled one at that, came down from the wilds of Yorkshire and was able not only to change the whole character of a city, but to make it a model of fine urban housing for all time?

XXI.

REGENT STREET, OLD AND NEW

IT is so easy, especially in middle age, to be for ever decrying the works of our contemporaries and praising those of our predecessors. This is particularly the case in an art like architecture, where old forms by continued use retain their meaning for centuries, and the significance of new ones is difficult to grasp. The temptation to condemn the new at once as upstart and vulgar is obvious. In comparing therefore the new Regent Street with the old, let us try to keep an open mind. What is it we have lost and what is it we have gained? Let us consider the former first.

Old Regent Street was our one definitely metropolitan street. By that I mean that not only had it a unity, although the individual buildings were by diverse hands, that no other street in London possessed, but it had a superior and welcoming urbanity. It was a smiling sunlit thoroughfare with restful architecture in large and dignified units. Being built in stucco, it could be repainted every spring, and consequently in pre-war days always looked bright and clean. The height of the buildings in relation to the width of the street was such that the sun could reach the façades and be reflected in the bright plaster. There were fine broad wall spaces, particularly in the curved walls of the Quadrant, in the Circuses, and in many of the blocks, which seemed designed to catch the play of passing light and shadow which is a characteristic charm of our climate. But better even than these general factors in the design was the courteous attitude of one building to the other. None were overpowering in height and outline; each deferred to the other by giving some echo of its neighbour in its scale, detail, or composition. The idiom used was of the utmost delicacy, suitable to the material, yet the ideas expressed were masculine and powerful. Each block was conceived like a palace stretching from side street to side street, broad and big in its parts and to a larger scale than any of the new buildings in the new street, however much taller the latter may be.

It was the aristocratic qualities of restraint and dignity, combined with a very urbane good-nature reflected from the brightness of the street and the easy flow of the buildings one after the other which made old Regent Street the happy, lovable place it was not only to London but to the whole Empire. Everyone remembered delightful walks there. To country cousins it was the very essence of the West End. For them it set the note and gave value to all that part of the town. It was, therefore, in every sense of the term, metropolitan. No other capital in Europe had anything like it. The

uniformity of the Rue de Rivoli or even of the Avenue de l'Opera was dull and mechanical in comparison. Starting at the base court of Waterloo Place, we saw that Nash had created a magnificent procession of fine shapes, rectangular places, recessed courts, avenues, circuses, the Quadrant and further avenues and vistas, and had lined them himself, and with the help of his architect friends, with a series of stately yet thoroughly English and lovable buildings—a unique achievement in the history of architecture. To the Regent, accustomed to the dark brick buildings which formed the mass of the London of his day, when he first drove down his friend's street it must have seemed as if Nash had possessed Aladdin's lamp and with it had created a new and glistening fairyland. To us who remember it before it was broken into, or its plaster and paint allowed to deteriorate, it seems to-day a lovely but almost equally unreal dream: so far has it already receded into the past.

Let us now turn to the new Regent Street which has taken the place of this unique and beautiful possession. Let us remember first that the conditions of control have remained the same. By this I mean that the property is still throughout Crown property, and that the control could have been as tight, and as wise, too, if the same wisdom had been used, as it was in Nash's day. The Commissioners of Woods and Forests, who administer the Crown Estate, now public property, pass all the designs and lay down any restrictions they desire. They can even impose designs and architects upon their tenants, as they have done in the Quadrant and are doing in Piccadilly Circus.

Let us consider the new street as a whole before we discuss any individual buildings. What is its character? What does it stand for in our civilisation? Has it anything to offer different from, but comparable in value to, the old? Let us take the most obvious effects first. The height of the buildings is different and much greater. So much sunlight will not now enter the street, and the general air of spaciousness is no longer there. The great majority of the designs no longer stretch from return street to return street. The units, therefore, are narrower, more closely packed, and jostle one another. Under such circumstances we cannot expect the same suavity, and we certainly have not got it. The chief place where the present controllers have tried to give it to us is in the Quadrant. We will return to that directly. Then the new street is in a different material from the old—in Portland stone instead of stucco. This has given the buildings a much heavier appearance and in itself is sufficient to alter the whole character of the street. On one side of the street the stone will go black. We can see that already in the Quadrant front to the Piccadilly Hotel. On the other, and in places where the weather catches it, we may expect the stone to take on the beautiful pearly quality Londoners know so well. Now that most of it is

white and clean it possesses at the moment a temporary advantage which must not be expected to last. Soon we shall have a black-and-grey street, with occasional high lights like Broad Street, Bishopsgate, or any other City street in the same stone. But it will be a street of big stores instead of the City banks, or of the little shops of old Regent Street.

As we walk down new Regent Street we can already feel its new quality. It is that of parts of Oxford Street, of Corporation Street, Birmingham, or of Lord Street, Liverpool. That is to say, it is a provincial quality. The street is no longer possessed by any dominant idea. The buildings do not harmonise and melt into a single whole. They bear the ordinary anarchic relations to one another we nowadays unfortunately expect everywhere else save in Regent Street. True, the main cornices are at one level, but it is often difficult to distinguish which is the main cornice, so complicated are the new designs. Domes and turrets breaking the skyline and other individualistic advertising features have been allowed. Kingsway, especially in the lower part, is informed by more general ideas, and consequently is a better street. It is this want of submission of the individual building and trader to the whole which has changed the character of the street, and has lowered it from its old high level to that of a commonplace bustling thoroughfare, efficient enough, no doubt, for those who consider it a suburban shopping centre, but not for those who would have wished to see it symbolise again some of the best aspects of our civilisation.

Let us give the Commissioners and their advisers credit, however, for trying in two places to produce a continuous design. Of one, Piccadilly Circus, re-designed as Piccadilly Square, it is too early to speak, except, perhaps, to say that the work already done shows a slightly countrified feeling very different from the abstract character of the old circus. Of the Quadrant, however, where, like all vacillating people who do not wholly know their own minds, the Commissioners changed from the irregularities they had allowed in Lower Regent Street to an attempt to impose upon the shopkeepers a continuous and highly monumental design, more can be said. From the section which was rebuilt some years ago as part of the Piccadilly Hotel, one can envisage the effect of the Quadrant as a whole, if, and when Norman Shaw's design is carried out. One can see that its character will be something very different from the old Quadrant. In place of that bright and happy spot, with its bold, sweeping, unbroken lines against the sky, we shall have a curved gorge lined with heavily articulated monumental architecture, of a municipal or governmental flavour. If the heavy arches are maintained the little shops will timidly peep out from beneath them. Few trades will survive such heavy-handed treatment. The little milliners and jewellery-sellers will have to give place, perhaps, to tombstone-makers and the agents for cemeteries. The gay character of the

street will certainly have gone. We shall emerge from this curving cleft in mountains of stone in no mood to saunter down the rest of the street, as in the old days. But who saunters by great stores? One takes an omnibus or a taxi-cab to the store one selects, plunges in and stays there, perhaps an hour buying anything from socks to tomatoes. The character of shopping has changed, and with it necessarily, the character of the street.

Nevertheless, I am convinced, even by certain of the new Regent Street buildings themselves, like Mr. Verity's fine St. George's house near Conduit Street, on the left-hand side going north, and some shop fronts by Mr. Arthur Davis—a perfumery, in particular, in Upper Regent Street—that had the best architectural brains of the country been employed on this new problem of giving appropriate character to a street of great stores it could have been successfully solved. The problem, however, would have had to have been boldly faced from the start, so that when we had lost the old unity we should have had a new one to put in its place. What we have achieved is but a few isolated, disconnected, and singularly unfortunate attempts at unity and a street which is no more and no less than any other English shopping street—a cockpit for competing shopkeepers. The Regent Street we have lost was definitely—almost infinitely—more than this, and by so much are we, who own and use the new, the losers.

XXII.

FIFTH AVENUE, NEW YORK.

FIFTH AVENUE is the most exciting street in the most exciting city in the world. At any rate, this is true in the daytime. At night, Broadway with its exaggerated Earl's Court effects, its great drawings in electric light high up against the sky of giant motor cars, pyjama-clad men and women, appearing and disappearing, is so fantastic and absurd, and withall so thrilling, that for a few hours round about midnight it displaces the other thoroughfare, not only for the careless multitude, but for the serious person, too, if such there be when he or she has once trodden its stones. Long after twelve o'clock vast crowds line its ample sidewalks, pour in and out of its endless theatres and its always open shops, and get carried away with the carnival spirit of its illuminated advertisements. It has its sky-scrapers, too, which Fifth Avenue has not, and these are always strangest at night. To see brilliant windows and towers of light floating in the sky, where ordinarily one expects to see stars, means that one treads the pavement in no solemn, downcast manner. One walks on air, not knowing what to expect. A vermilion giant may suddenly grin at you in place of the moon, and if you stand agape you may, with equal suddenness, find yourself surrounded by artificially brightened eyes from all parts of Europe. Certainly, Broadway has its thrills with which Fifth Avenue cannot compete. It would, of course, scorn to do so. Its wonders are for the saner hours, when Broadway, in its turn, is apt to look a little dingy.

Let us return, therefore, to our proper subject, and try to form some general idea of its ordinary aspect. I think if one imagines a deep, dark, strongly flowing river, gliding swiftly and silently between great white cliffs of varying height, one will come near to it. The surface of the water is black with occasional spots of green. The black is due to endless streams of sleek, satin motor cars, eight abreast, in four lines either way, which all glide along at the same pace. The green is due to the motor omnibuses, free from all advertisements, which dot the surface. I have not seen a horse-drawn vehicle in Fifth Avenue—perhaps they are not allowed. The black river surface, which flows on for the five miles or so of the street, has an occasional rock in the centre of it. These rocks, which are really wooden towers from which the traffic is directed, are placed on the crests of the slight rises in the undulating surface of the street—I am afraid my metaphor is failing. In them a big green or red light shows night and day, and with its appearance the whole five miles of river suddenly stops, or

equally suddenly, flows on again. When it stops, the waters divide, and vast crowds—mostly Israelites as of old—pass over dry shod. Only those who inhabit the land of the brave and the free would allow themselves to be so strictly regulated in this and other matters. But we have spent enough time on the stream itself, thrilling as it is to watch; let us examine now the perpendicular cliffs and the shore on either side.

The cliffs in the early part of the street are more even in height. They begin with some old residences, revived in recent years as the homes of artists, but very soon are chiefly inhabited by agents for dry goods. By Twentieth Street, however, hotels and big stores begin, and the street loses such continuity of skyline as it ever possessed. From there onwards it is a series of strongly competing buildings which rarely extend even across a whole block. The effect, therefore, against the sky is very ragged, like an ill-grown set of giant teeth. No long cornice lines run through. There are no continuous roofs—indeed, very few roofs at all to be seen. In a sense, therefore, it is not a street at all, only a collection of buildings, just as a checker-board town, like most of New York, is not really a town at all, but only a collection of city blocks. Unity of some sort, some continuous thought or character, is required for both. It is this lack of unity which makes Fifth Avenue at once so exciting and so tiring. One never knows what to expect, there is no place for the eye to rest without distraction. If the individual buildings were bad the streets would be a nightmare. As it is, they are extraordinarily good, and the street becomes a museum of fine specimens, and one knows how tiring that may be.

These specimens represent European architecture of many modern phases. French and Italian predominate, English is conspicuous by its absence. Gradually, however, especially in the banks and in buildings over ten storeys high, for which no European precedent exists, a true American type is beginning to emerge. Roughly, it consists of a rich group of stories near the ground and an equally rich group near the top, with a plain stalk between.

One of the earliest good buildings round about Thirtieth Street is that for the famous firm of jewellers and glass-workers, Messrs. Tiffany. I am told that the founder of the firm was a Venetian merchant. If so, his architect very appropriately founded his building on the Grimani Palace on the Grand Canal. He founded his scheme upon this; he did not copy the original, as is often ignorantly stated. Instead, he made a peculiarly refined building in marble and bronze, using the general composition and great scale of the Italian building as his model. A palace on the Grand Canal, with its rectangular shape and great size, is singularly like a big building on this other great canal of wealth and traffic. The same firm of architects, Messrs. McKim, Mead and White, built the Italian building for a rival firm

of silver-smiths—the Gorham building—on the opposite side of the street. This building has a giant cornice and an open belvedere under it, and though built twenty-five years ago, and consequently an old building, probably in danger of destruction, it is still one of the most striking in the street. Between Thirtieth and Fortieth Streets are most of the big stores. Unlike similar buildings in England, these are solid masses of stone, brick or marble architecture standing squarely on stone piers, instead of, apparently on plate glass. These stores do not seem to rely, as ours do, on the multitude of goods shown in the windows. Everyone knows that it is possible to walk through them and examine the endless counters without being asked to buy. The windows, therefore, can have one or two typical or seasonable articles well shown. Later on, as we approach the Central Park, the shops become more specialised, and consequently smaller. Here are the dealers in pictures, in jewellery, in *bric-à-brac*, and very exquisite are their bronze windows, and indeed, their whole fronts. Gradually they are displacing the private residences from this section of the street, although a few multi-millionaires still maintain a French château or so, mostly closed, for the delectation of the rubber-necks.

With the Central Park, however, the character of the street entirely alters. One cliff disappears, and in its place you have the small trees, grass and taxi-cab race tracks of the park. On the other side you have individual houses, a few very vulgar, most of them very restrained and elegant. The park itself, though, is a failure. Its winding drives and small hummocks of hills cannot hide its rectangular shape, which the increasing height of the buildings is every day making more evident. It should be all levelled into terraces and relaid out in a formal manner. Fifth Avenue practically ends where the park ends at 110th Street and before then begins to degenerate. But out of its five miles of length it has maintained its standard of fine if competing architecture for three miles, and I know no other street of which that could be said. Apart from the green of the park, there is one restful thing which we have passed by. It is the one building of a non-competitive character, with nothing to sell—material or spiritual—the free public library. It occupies at least a couple of city blocks, and sets back from the street with low cream-coloured marble façades and porticoes. Though not entirely successful as a design, except in the rear façade to its stack of books, it comes as a very pleasant break to the commercial buildings, where between Thirty-ninth and Forty-second Streets they reach their maximum intensity.

It is not only the vast scale of the street as measured by its width, which seems enormous when one looks at the sea of traffic, but which seems narrow when one looks at the towering buildings, nor the beauty of those buildings or the delicacy of their detail that give Fifth Avenue its peculiar

character and interest. Without the great masses of well-dressed men and women which crowd its wide pavements all day long it would seem dull and heavy. I have noticed that on Sunday mornings when searching for its half-buried cathedral and churches. Nowhere else have I seen such floods of beautifully-dressed women. They appear, too, to belong to all classes of society. It is only by some subtle and slight restraint in the line of a cloak that one can distinguish the woman with a few generations of wealth behind her from the stenographer or shop assistant. All wear fashionable clothes, all have brilliant complexions. The men are not so distinguished, but none are poorly dressed. Indeed, in all New York, from the furthest east to the furthest west, I could find no one in torn or dirty clothes. The air of prosperity is everywhere, the rush and flow of life goes on unceasingly. There is only one backwater, only one place where the competitive view of life is put aside. It is in the interiors of the clubs, such as the Metropolitan, the University, the Century, the Union and the Players. Here the very reverse is the case. I know no clubs in any town so spacious, so reposeful, so dignified and so pleasant. I imagine, the human spirit tired of endless competition and the unceasing striving of the individual to assert himself, instinctively makes a refuge where communism in the arts of living reaches its highest point. Some of the best Clubs are in Fifth Avenue or just off it. When one has had an overdose of the street they are the only restoratives.

XXIII.

LIVERPOOL CATHEDRAL.

LIVERPOOL has now entered into possession of a great work of the imagination. This work will go on growing until its mastery is evident to the whole world, but from now onward Liverpool can follow the growth of her Cathedral with confidence. It is no small thing that a great town should pursue an ideal of this sort. In doing so, Liverpool has herself shown something of this great quality of imagination. As a citizen I like to think whatever may be her failings, it is her outstanding attribute. During the last twenty years she has not only taken the great step, which she has lately celebrated, towards the creation of a temple to her faith, to be, I believe, some day as great and as noble as any yet made, but during the same space of time she has had the imagination and faith to follow other enterprises of this spirit, such as the establishing of a great university, and, among lesser projects, but still indicating something of the same devotion to non-material things, a town's theatre. If the artist who has been responsible for giving life and form to the Liverpool Cathedral has risen to the heights demanded by so supreme an occasion, we must, nevertheless, remember from the outset those who have had the courage during these years to conceive the project and to provide the means for its realisation on such a scale unattempted since the Reformation. They, as well as Sir Giles Gilbert Scott, have laid the whole town under an obligation and have done a service to us all. Pericles built the temples on the Acropolis, at Athens, to direct the eyes of the Greeks, flushed with the spoils of victory, away from material things. To all Liverpool, irrespective of creed, the great building on St. James's Mount, in its austerity and beauty, is a similar symbol and a similar gift.

Before the architect came on the scenes the site was chosen. Those who were responsible for this, against a good deal of popular clamour, deserve well of the town. No English Cathedral, with the possible exception of Durham, has so romantic a setting when you get near to it, while no other site would, in my view have provided so good a position from which the Cathedral could assert itself and what it stands for to the whole Merseyside. Already in its present truncated form it is a dominant object from the river, though there is one unfortunate grain elevator below it on the river bank which, in its present shape, seems to mock it. When its great tower, however, is completed, and its whole monumental mass is seen grouped symmetrically about it, with its subsidiary buildings at its base, like

attendant tugs to a liner, it will, I think, focus as it should the interest of all the river views. It is fortunately separated from the great commercial buildings at the Pier Head, and the vaster and loftier ones which are yet to arise in that neighbourhood, by a considerable distance and a slight depression. The business quarter of Liverpool, like that of New York, being tied to certain centres, there is likely, for a century or more to come, to be an intervening space of comparatively small buildings between the Cathedral and the only structures which may possibly rival it in height or bulk. This is very important. It would be fatal to confuse two such different aspects of the town's life.

Near at hand, and under its wing as it were, the Cathedral has the one solemn graveyard Liverpool possesses where many of the citizens of its great period are buried. It is a graveyard, too, of great romantic interest, in the base of an old quarry with lofty sides, from whose stone most of the older buildings in the town have been built. On one side is the Piranesi-like wall supporting Hope-street, lined with sloping walks and the arched entrances to vaults, while on the other is the old quarry cliff, in summer green with trees, on which the cathedral stands. It is among the great merits of Sir Giles Scott's work that it suits itself so well in detail to this foreground, just as in bulk and outline the finished design will suit itself to the larger picture of the town as a whole. There is a cliff-like character in the bold faces of the transepts which echoes the cliff below. But it is more than that. The horizontal mass of the building, which is emphasised in a way quite unusual in a Gothic structure, tallies very happily with the horizontal mass of the great stone base which the face of the quarry forms. The greenery on this base, too, well sets off the colour of the red Woolton stone, while in the depths below among the winding paths there is hardly a single white marble tomb or angel to form a jarring note. If there is, time has softened it to obscurity, and now that the Cathedral authorities control the graveyard we may be sure no new ones will arise.

So much for the site. Let us now consider for a moment the scheme for the finished exterior as the architect has planned it. Most people remember the interesting design with twin towers over the two transepts—there were only two contemplated in those days—and the high roof connecting them with which Scott won the competition. A great feature in this design was a series of gables along the chancel and nave roof-line like small transepts. These have all been eliminated in order to get greater horizontal character, together with the twin towers themselves, whose somewhat obvious picturesqueness appealed to so many people. Gradually the present symmetrical design has been evolved as the architect has got deeper and deeper into the work. It has been a matter of long and mature thought. Let us recall for a moment the stages. The old design I have just described with

its somewhat restless and irregular outline, but with its strange power and novelty, was the work of a young pupil in an office hardly out of his teens. The judges, Mr. Norman Shaw and Mr. Bodley were strongly in its favour. Nevertheless, it is on record that the committee would not accept it, and, indeed, refused to accept any of the five final designs. Especially they felt they could not go to a young man who had as yet built nothing. Finally they persuaded Mr. Bodley to be joint architect. The latter has often been blamed for accepting the position, having already acted as judge, but only by his doing so did Sir Giles Scott and his design survive. For five years they worked together and then Mr. Bodley died. There is a large and elaborate model in existence which shows the stage reached in their joint work. To my thinking it is Sir Giles' original design tamed down and prettified. Large traceried windows appear everywhere. However, when he was free, he reconsidered everything. If there is any Bodley left, it is in a few mouldings in the Lady Chapel. The main Cathedral is entirely Scott, and the merit or otherwise that is in it, is his alone.

The work, whether we like it or not at first glance, is obviously something new in Gothic architecture. The whole development of medieval Gothic was in the direction of eliminating the wall surfaces. It achieved this by a sort of skeleton construction of lofty piers, arches, vaulting ribs, and flying buttresses. Great glass windows filled the interstices, and these themselves were articulated by stone mullions and tracery in the same linear way. The resulting structure was an intricate scheme of thrusts and supports. Everything was propping something else up. If you pulled out one support the whole would in logical theory come tumbling down. The scoffers said the Crystal Palace was the unseen goal. Certainly, whatever hard qualities such an engineering style contained were emphasised and increased by the archaeologically-minded architects of the Gothic Revival of last century, not least among them in this respect, by Sir Giles Scott's grandfather, Sir Gilbert. Here, however, at Liverpool, we have something quite different. Although the boney structure of piers and arches, and ribs is there, the architect has clothed it with flesh. The most obvious characteristics of his exterior are its mass and weight. A shell might knock a hole in it, but there would be no danger of its falling. Instead of his building appearing a piece of fairylike construction, as many of our old Gothic cathedrals do, or a thin cast-iron triumph of engineering as some of our modern churches, Sir Giles' building has the massiveness and almost the repose of a great Roman structure. It appears, from a little distance where the joints cannot be seen, as if it were carved out of the solid, part almost of the rock on which it stands.

This breadth and solidity which will be still further increased when the symmetry of the finished building can be seen is a new quality in Gothic

architecture. It is one which is looked for rather in classical buildings. It seems to me, therefore, in adding this quality to Gothic, Sir Giles has rescued Gothic from a dead end and given the style a new life. On the old lines it could only get thinner and thinner, more and more wiry and linear. Now, however, by his plastic treatment, Gothic can be made almost as broad and restful, as welcoming and urbane in its effects as classical architecture, and yet retain its essentially romantic character. I should like now to see the same architect design a great banking hall or railway station. I believe he could give them all the necessary breadth and dignity and yet infuse them with new vitality and interest. By making too his building ultimately a perfectly symmetrical structure, he has given his Gothic structure a monumental character which will be a further distinguishing mark. We all know how the Gothic cathedrals, particularly in France, rise as great piles of masonry and glass above the roofs of the town. We know, too, however, that unless we are looking straight at the west end, with its symmetrical composition, how ill-balanced they often appear; the strong square towers at one end and rounded chancel at the other shored up on every side by an intricacy of flying buttresses. The Liverpool building, with its square-ended nave exactly balancing in length its square-ended chancel, with its pairs of square-ended transepts on either side opposite one another and forming a base from out of which the great wide tower rises, will make a balanced monument from all points of view. This is a character then, to which we are not accustomed in Gothic architecture, but one at which most classical buildings aim. Folk have gone so far as to say Sir Giles has classicised Gothic architecture just as they said his American confrère, the late Bertram Goodhue, who stood to American architecture very much in the same way that he does to English, Gothicised Classic. Both statements are, of course, an exaggeration. Sir Giles has not produced any hybrid building. What he has done has been to enlarge the scope of a certain style in architecture, and in so doing he has put all architects into his debt. This development of Gothic which he has brought about, will, I am convinced, when seen by the historians in retrospect, be the distinguishing mark of our period. If I am right in this it is an even bigger thing to have done than to have built the Cathedral.

In judging the exterior as it is to-day, it is very necessary to remember what the finished building will look like. When this is thought of, certain things which may seem to stand up rather crudely now, like the two turrets at the end of the chancel, will sink into their place in relation to the whole. The great chancel itself, so massive and rock-like, has indeed rather a stocky appearance. To understand it, it must be imagined as a sort of porch to the great group of the four transepts and the central tower. Looking at it from the corner of Hope Street and Upper Parliament Street—one of the best points of view—we see it rising out of the quarry with the Lady Chapel on

one wing and the Chapter House on the other, with galleries of vestries and halls about its base, with the great solid buttresses rushing up to the roof. It is a complicated but solid mass. Think, then, what this will mean when the great tower rises behind it, so that the whole of the present chancel seems but a supporting block at its base, a little bigger than the other supporting blocks, the transepts. Think of the tower as beginning in strong, massive walls above the great arches connecting the transepts, and then gradually breaking into greater and greater complexity as it masters the building and rises clear above it, to dominate not only the Cathedral but a large section of Liverpool. I can think of no building which will have such a dramatic climax as this, and because of this I can think of no more inspiring gift for a rich man to make to Liverpool than the gift of this tower.

Then if you walk down under the building along St. James Road you meet almost equally dramatic effects. The great transept rises sheer like a cliff from the wide spread of little steps at its foot—of ordinary size really—while there projects in front of you at one end of these steps a strong, massive porch, with deeply-moulded doorway and Piranesi-like grille. Everywhere there is drama, but it is drama well controlled. There is nothing nightmarish or extreme, though there may be some youthful excesses, especially in the Lady Chapel. Indeed, one of the greatest interests of the Lady Chapel to-day is to see by means of it how the architect and his architecture have grown both in power and control. I heard someone once say that he liked the outside of the Cathedral because it was so ugly. Ugly and pretty are dangerous words which mean very little in themselves, but I think the person I overheard was getting at something real by his remark. He meant the building had character and force. It has this everywhere. The great lines of the design will not be seen till it is completed, but from every part of the present exterior one can feel the strength of the mind and the adventureness of the spirit which have conceived and moulded it.

With the interior one reaches a different plane. I find it very difficult to speak about it, for I admire it so much. Admiration is not the right word. It overawes me. Yet that is not quite right either. I feel a worm when I first enter the building, but I always come out of it with a feeling of great happiness and exaltation. One cannot explain a great work of art as I feel this interior to be. It must make its own blow upon the mind. Such an interior as this must succeed or fail with the first impression. One may find all kinds of additional beauties later on, but an interior, however vast, must compose into one great whole. There is no doubt this does. The exterior will when we see the tower. This does so already. I do not mean that when the vistas are lengthened and the great central space formed that the picture will not be more wonderful and more complex. I doubt, however, whether it will be more intense. As you look now towards the altar and see the great

piers rising majestically on either side and the dim spaces between them, so deep and lofty that the atmosphere and the stone seem to take on a bluish tone, when, too, you look at the vaulting growing out of the great arches and piers, with no intricacies of a triforium gallery to break the lines, you feel you are in some great organic structure that has grown to its inevitable shape by some law of its own being. The old cathedrals have endless beauties of construction, of craftsmanship, and, one must add, of accident. Liverpool Cathedral has an intellectual beauty of its own, due, I suppose, to its being the design of one man, who has felt intensely and constructed fearlessly, and who all the while has had a clear grip of his ultimate intentions, however much from time to time he may have varied his approach to them. I do not want, however, to suggest for a moment that there is any intellectual or logical coldness about the Cathedral interior. It is austere and grand, on a scale we have not seen before in England, but it is not cold. Look at the east end. The reredos, with its multitude of figures, its filigree work and gilding, seems to be bursting into flame, and the rich colours of the great window carry on this effect. The spacious floor in front, with its quiet harmonious colouring, makes this burst of glory all the more impressive. Everywhere, indeed, in the chancel, but not affecting the bones of the design, is a rich underpattern of carving in wood and stone, admirably blended. One may cavil here and there at a detail—I do not like all the figure-carving myself, I think some of it is too pretty—but who ever read a great novel and did not find a word or sentence here and there which one imagined might be improved?

The view along the vista of the transepts, is as fine as down the chancel. It is almost as dramatic and more austere. The war memorial altar and its reredos stand out as fine incidents, but do not interfere with the repose. The same may be said of the organ fronts to the transepts. Let the eye run up from the great strong mouldings of the stone arch to the little perforated wooden valance below the organ gallery and then to the gallery itself. It is one dramatic and romantic contrast after another. Then, again, above are the great pipes and their delicate pierced wooden cases. Indeed, there is a sense of drama everywhere, not, of course, in any cheap theatrical sense. All life is drama, and if this building had none it would be dead instead of the living and vital thing it is. Notice how nobly, yet dramatically, the bishop's throne stands up out of the gloom behind it, or how the single great central mullion in the transept windows dramatically closes the vista, but notice most of all the play of light and shade in the chancel from the hidden windows in the aisles.

As you enter you only see the three great terminal windows, but you feel the effect of the others on the walls and piers, some lit, some dark. The electric lighting of the chancel at night from behind the great piers will have

something of the same effect. It is a splendid and mysterious effect. If one saw it in an old building one would say at once that it was a great and splendid effect reached no doubt subconsciously, almost, perhaps, by revelation. Let us not refrain, then, because the architect lives amongst us and is of our generation—indeed, younger than most of us—from giving him credit and honour for having made all this mystery and beauty. It is not calculated beauty like certain stage effects which can be reproduced at any time, but is deeply felt beauty. More and more as one looks at the building one realises the strength of the imagination and the nobility of the mind which has conceived and made this great thing for Liverpool. If Liverpool has shown faith by her enterprise she has been rewarded by her architect beyond measure.

XXIV.

DUBLIN IN 1924.

A CITY so beautiful as Dublin may survive a couple of wars within as many years, but can it survive the peace which now possesses it? This is the question that has haunted me since a visit recently paid of a few hours duration. There were the same spacious squares of trees and grass surrounded by broad-faced reticent houses, the same wide streets of ample dignity, there was the same river with its fine stone bridges—a river lined indeed with the ruins of the town's two noblest buildings, but hardly less picturesque because of that; you approached the city from the sea through the same magnificent bay, with the same fine coast line with its stately headlands on either side, and the mountains and parklands behind. Yet the city itself was different. It wore a different air, it carried itself with a different spirit. Superficially it seemed down-at-heels, yet jaunty withal. One would not mind the down-at-heels atmosphere, but jaunty self-complacency is another matter. One is accustomed to decay in many a beautiful Italian town. The decay of beautiful things has in itself an element of romance. Even artificial decay sometimes possesses this quality. I found the battered Four Courts interesting in a new way. They had the interest that the ruins of ancient Rome had, before they were cleaned, garnished and labelled by the archæologists—the interest they still have in Piranesi's etchings. You saw at the Four Courts pieces of magnificent carving, perhaps a trophy of arms over a doorway, against a disorder of broken walls. The carving seemed thereby to possess a new and more vivid life. It looked as some French courtier might have looked in his brocaded clothes among the debris of the Bastille. Besides the Four Courts can be repaired, and I suppose even the lost dome can be restored to the Customs House. Till the latter is done, however, the city is definitely the poorer. Its absence is a gap that is felt acutely. The pierced dome of the Four Courts is but a reveller whose fine clothes have been somewhat torn and muddied, but who still keeps his feet and even adds a little ironic gaiety to the scene. But the Customs House, as a whole, is laid low by its loss. Without its dome— the envy of all non-metropolitan towns in spite of their modern attempts— the great building is in the gutter. Its massive walls and columns remain, but they have lost their meaning. The long façade straggles on with nothing to hold it together. With its dome it was the most powerful yet buoyant civic building in these islands. Now it is not only prostrate but dull. But Irishmen will, I know, see that these two buildings are restored to their pristine grandeur. The uneasiness I feel about the town is not due to them nor to

ruins of whole sections to cellar level as at Ypres or Albert. It is due rather to the innovations, to the new red Ruabon brick buildings in Sackville Street, to the sixpenny stores in Grafton Street—the Bond Street of the town—to the coarse granite Celtic Cross in front of the beautiful Leinster House as a memorial to Michael Collins. Was any hero so badly served by those who meant so well? I would have taken Nelson off his column if I could have done no better, or I would have gone to America for another Parnell monument. It is this acceptance of the second rate which frightens me in a town too, which, till now, has possessed more for its size that is first rate than either London or Edinburgh. It may be a passing phase. The best architects of the town are desirous enough to do well if they are employed. The republican spirit, which prevented both the railway porter, who found me a seat in the mail train, and the boots at my hotel from taking my modest tips, will in time find its due expression. So far it has not done so, at any rate in material things. Rather it has been content with a bourgeois vulgarity which even Lancashire would scorn.

Perhaps it is waiting till the last of the Sassenach has disappeared. I hope they came away on my boat—three women in monocles and a man dressed as and with a face like a horse. But there was something too in the remark of the jarvie who drove me on his car to Westland Row, "What's wrong with this town is that it has too many darned heroes." Certainly if all these heroes have monuments erected to them like poor Michael Collins's there will be no more Dublin. No town could stand such treatment, least of all one whose charm is so finely gracious, and who is at heart so truly aristocratic. Dubliners could at any rate no longer gibe as pleasantly as they do now at that northern city with its one book shop, if their own became but an expression of the rivalries of petty commerce relieved with a multitude of barbaric monuments.

AUTHOR'S NOTE.

The Author begs to thank the Editors of *Architecture*, *The Manchester Guardian*, *The Observer*, *The Weekly Westminster*, *The Liverpool Daily Post and Mercury* and *Country Life*, for permission to reprint articles which have appeared in their papers.

Milton Keynes UK
Ingram Content Group UK Ltd.
UKHW011124180424
441376UK00004B/196